POSTCARD HISTORY SERIES

Wichita

Wichita

James E. Mason

ARCADIA
PUBLISHING

Published by Arcadia Publishing
Charleston, South Carolina

Printed in the United States of America

Library of Congress Control Number: 2012936605

For all general information contact Arcadia Publishing at:
Telephone 843-853-2070
Fax 843-853-0044
E-mail sales@arcadiapublishing.com
For customer service and orders:
Toll-Free 1-888-313-2665

Visit us on the Internet at www.arcadiapublishing.com

This book is dedicated to all the people of Wichita, past, present and future.

CONTENTS

ACKNOWLEDGMENTS

One source of inspiration for this book is its illustrious predecessor *Peerless Princess of the Plains*, created in 1976 by three Wichita postcard collectors, Hal Ross, Hal Ottaway, and Jack Stewart. It was one of the first books ever produced to solely use picture postcards as a means for presenting history and deserves recognition for that reason alone. But in addition, the authors' personal knowledge of the people involved with the buildings, businesses, and events shown on the cards gives the narrative captions an insider's viewpoint not often found in history books.

The second source I must acknowledge is Dr. Edward Tihen, a local history buff who scanned through more than 100 years of microfilm reels of the two principal local newspapers, the *Wichita Eagle* and the *Wichita Beacon*, and took notes on the local events they documented. The Tihen Notes, as they are called, were donated to the Special Collections Archives of the Wichita State University Library and are available on the library's website. This unique index of Wichita's past has not, to my knowledge, ever been duplicated in any other city. Dr. Tihen was also a postcard collector, and whenever he found information in the newspapers related to the cards with Wichita views, he made sure to jot it down. The Tihen Notes were essential for my research.

Dr. Tihen's extensive collection of postcards was donated to the Wichita/Sedgwick County Historical Museum, as were other local postcard collections. This trove of material helped me to fill in the gaps in my own collection for the purposes of this book. I thank Jami Frazier-Tracy for assisting me in the selection and scanning of those images, and for patiently replying to many inquiries on all manner of subjects. Jeff Roth, a fellow local history buff, provided other missing postcards and helped explain some I was puzzled by. Hal Ottaway had the remainder of the cards I needed.

I thank Sister Charlotte Rorhbach for elucidating the complex history of Newman University.

Unless otherwise stated, all postcards shown here are from the author's collection.

INTRODUCTION

Looking back at the past through the lens of picture postcards is a way to view scenes long gone from living memory. This book presents a selection of picture postcard views of Wichita during the early decades of the 20th century. Many facets of life in Wichita in those years were recorded by picture postcards, as was the case all around the country.

During the years before Kodachrome film was invented, these colorful and durable printed images provided a way to share realistic views of one's hometown, and other places one visited, with friends and relatives. They were inexpensive, cost only a penny to mail, and immediately became very popular right after they were introduced, shortly after 1900. This popularity resulted in a booming postcard industry, which created cards with numerous views of every town in order to cash in on the new craze. Businesses made ample use of postcards as a means of advertising, providing a third impetus for their proliferation. While picture postcards were often a form of commercial advertising, major events, pastimes, and local scenery were also subjects. By 1913, a little more than 10 years after they were introduced, the US Postal Service reported that a billion cards were being sent each year.

The first three decades of Wichita's existence, from 1870 to 1900, were not documented by picture postcards, but some photographs taken then were reused on postcards later. Many landmark buildings constructed in Wichita during that time were still in existence, and their photographs were used to create postcards. Some of those buildings exist even now. Many are gone, however, so the postcard images of them provide valuable documentation of their existence. Of those buildings that remain, many are in the National Register of Historic Places, and 23 of them are featured in this book. The grandest of those buildings were constructed during the real estate boom of the late 1880s.

Of all the milestones in Wichita's history, the boom stands out from the rest. A wave of land speculation flooded the town with money. New additions were platted rapidly, leap-frogging each other in all directions. In 1887, the dollar volume per capita of real estate transactions in Wichita exceeded that of any other city in the United States.

Not just one but several new colleges were proposed in Wichita, which only had a population of 32,000 people at the time. During 1887, six institutions of higher learning began constructing campus buildings amid talk of Wichita becoming the "Athens of the West." Hannah Rea Woodman, daughter of one of Wichita's founders, wryly wrote in a retrospective article for the *Wichita Eagle* published on April 18, 1949, that Wichita in the boom years had "cultural high blood pressure." Most of the colleges were promoted by real estate speculators who hoped each college would be a catalyst for residential development in the property the speculators owned

nearby in the booming city. Two never rose above their foundations. One was sold to the Catholic Church. Another two were restarted before 1900 after changes of ownership. Only one came intact through the depression of the 1890s.

Wichita's speculative bubble deflated disastrously in 1888–1889. Many people and businesses went bankrupt, as did several banks. Monumental buildings were left unfinished and vacant for years. Some were never completed and were sold for scrap. Half-completed homes sat abandoned on the outskirts of town on "streets" that had been staked out and graded once, then left to grow up in weeds. Dozens of dwellings in the suddenly remote additions were sold, picked up, and moved to new addresses closer in. A few boom-era additions such as Riverside and College Hill eventually became—decades later—what their developers had envisioned. Other additions only exist as faded plat maps in the file drawers of the County Register of Deeds.

By 1900, Wichita was beginning to recover from the real estate bust and the decade of economic depression that followed. The following four decades, from 1900 to 1940, were a time of great growth. The discovery and development of the nearby El Dorado oil field helped fuel the growth along with the expansion of flour mills and meatpacking plants. The population grew from 24,000 to 116,000, and the birth of the aircraft industry in the 1920s set the stage for further growth in the years beyond. All of this change and progress produced numerous subjects for picture postcards right when the medium was coming into vogue.

The birth and development of the health care industry in Wichita was an important part of these decades. At first, the town had only physicians working out of their homes or downtown offices. They would sometimes travel miles out of town by horse and buggy to treat patients. The first institutions devoted to health care arose in the mid-1880s. By 1920, there were three substantial hospitals in Wichita. Eventually, those hospitals developed into regional medical centers, and numerous specialist practices were established. Today, health care is the second largest sector of Wichita's economy in terms of total employment.

Postcard manufacturers typically used photographs for the front image for the sake of verisimilitude. But photographs were only available in black and white at that time. Usually—although not always—the publishers embellished the images to create views in color. Sometimes this was done with breathtaking realism but other times crudely or with considerable artistic license, which limits their reliability as historic documents. However, by comparing different postcards with the same subject and by looking at contemporary photographs and written accounts, one can usually sort out the truth contained within each image.

Eastman Kodak and some other film manufacturers came out with special card stocks that made it possible for anyone to create a postcard using their own photographs, resulting in real-photo postcards. These images were absolutely true to life and are especially prized by historical postcard collectors for that reason and for their one-of-a-kind nature. Several of these unique images are presented here.

People in distant cities exchanged cards with each other as a special form of pen pals. The treasured mementos were saved in scrapbooks, albums, and shoeboxes and thus preserved for us to see now. The brief notes written by the postcard senders offer intriguing glimpses of the times in which they lived.

Please join me for a stroll around Wichita in the early 1900s, courtesy of the people who collected and preserved the picture postcards that recorded these scenes for posterity.

One

DOWNTOWN VIEWS

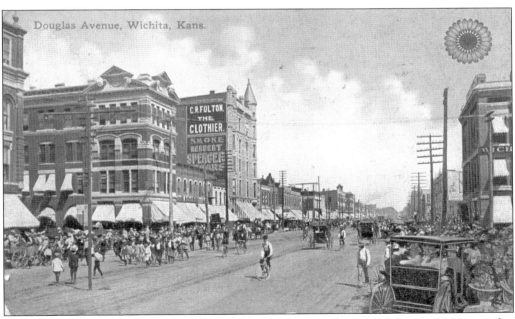

Douglas Avenue was established early on as Wichita's principal thoroughfare, and 30 years after the founding of the city, it was the heart of downtown. Consequently, many different postcard views were produced of it. This view looking east from the first block of East Douglas Avenue shows a busy day with not a car in sight. The large sign painted on the upper west wall of the Winne Building advertises the clothing store Clarence R. Fulton had on the ground floor there from 1896 to 1906. The sign below it touts Herbert Spencer cigars. There were 12 cigar stores in Wichita in 1905.

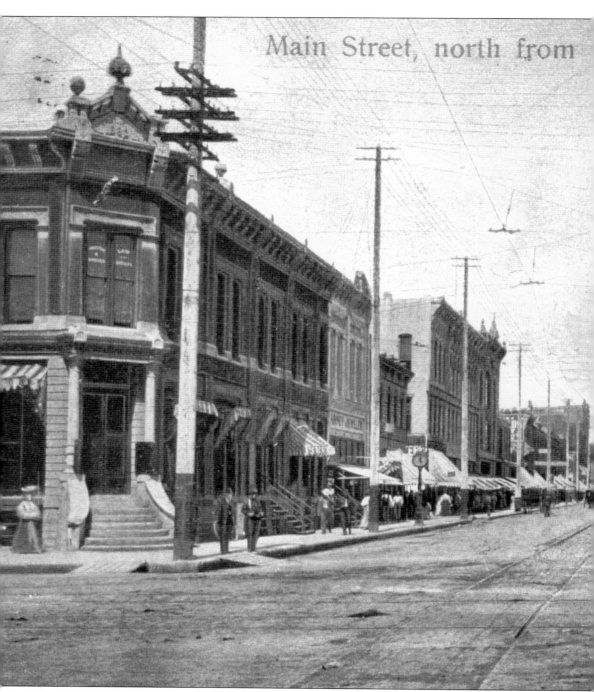

Seen here around 1908 is the Citizen's Bank Building, completed in 1884 on the northwest corner of Douglas Avenue and Main Street. It was replaced by the First National Bank Building in 1922. Just north of that, the sidewalk clock in front of the Varney Jewelry Store at 109 North Main Street reads 25 minutes past noon. Overhead, a spider web of electric wires provides power for the two tracks of the streetcar line. The 1874 two-story brick building on

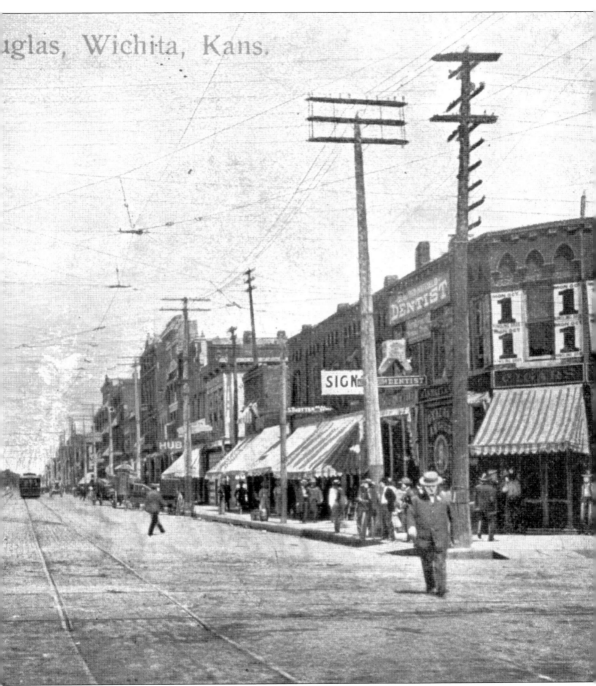

the northeast corner of the intersection was occupied for many years by the New York Store, a dry goods emporium. At the time of this image, it was occupied by a cigar store. Both this and the Citizen's Bank had beveled corners fronting onto the intersection. It was replaced with the Schweiter Building in 1910.

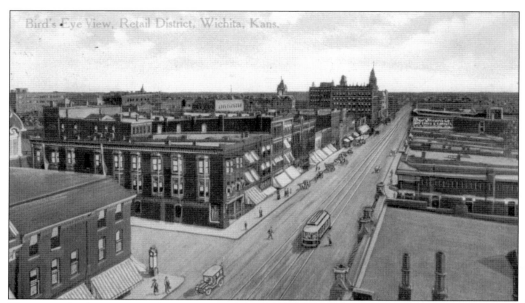

This view looks southeast from atop the five-story Morris Building, formerly at 213 North Main Street. The building on the left with the distinctive tower, at the northeast corner of Main and First Streets, was a bank when it was built in 1872 but housed the county offices from 1877 to 1890. The building across the street with the second-story bay windows was built in 1887 as the Hotel Gandolfo. All three buildings are gone now.

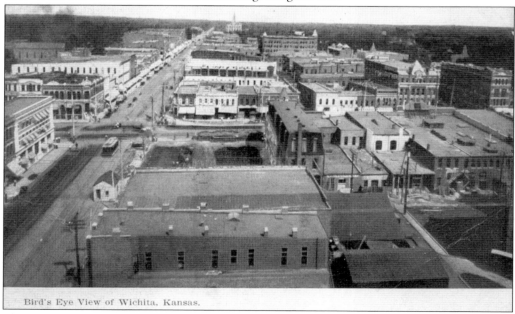

This postcard from September 1906 looks north from the top of the old city hall and captures the brief time when the southeast corner of Douglas Avenue and Main Street was empty, after the Eagle Block was demolished and before the construction of the Boston Store. Excavations for the foundation of the Boston Store began that month. The county courthouse is visible on the horizon.

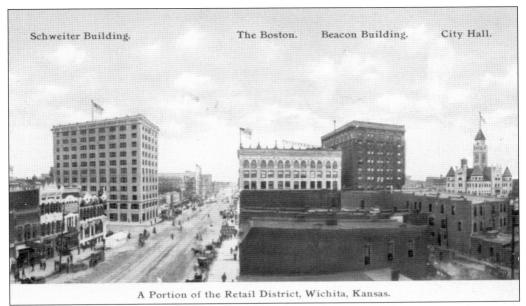

Schweiter Building.　　　The Boston.　　Beacon Building.　　City Hall.

A Portion of the Retail District, Wichita, Kansas.

Most of the western part of downtown was never shown in postcard views. Here, that area is just the foreground to the principal structures on Main Street. But the buildings along the first two blocks of West Douglas Avenue had some interesting 1880s architecture, some of which can be seen along the north side of the street in this view from between 1911 and 1922.

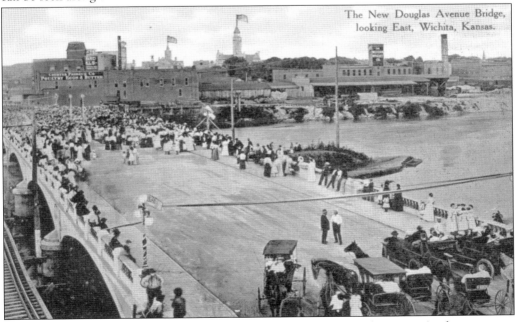

The New Douglas Avenue Bridge, looking East, Wichita, Kansas.

The Douglas Avenue Bridge over the Arkansas River was the principle connection between east and west Wichita. When it was replaced in 1909, it was a major event. The dedication ceremony, seen here, was on July 12, with James R. Mead as the main speaker. This view looking east shows Courter Produce Company, Howard Mills, and the Western Biscuit Company on the east bank where A. Price Woodard Park is now.

This 1930s postcard view looks east toward downtown from the Broadview Hotel. In the left foreground is a White Castle hamburger stand at 318 West Douglas Avenue. The Pacific Hotel sits directly across the street from the Missouri Pacific Depot. All the buildings in the foreground were demolished between 1960 and 1970 during the urban renewal era.

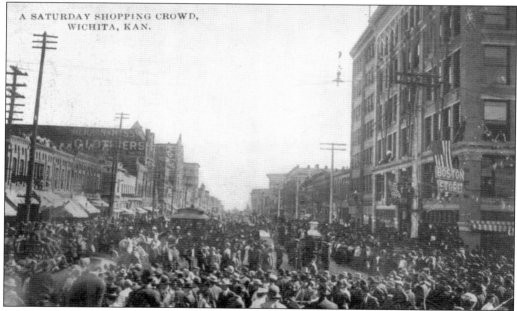

A SATURDAY SHOPPING CROWD, WICHITA, KAN.

Downtown Wichita could be a very busy place, as seen here on the first block of East Douglas Avenue around 1909. While this throng of people was purportedly a Saturday shopping crowd, it was more likely associated with the Peerless Prophets Jubilee, a weeklong festival held downtown in early October between 1908 and 1911.

14

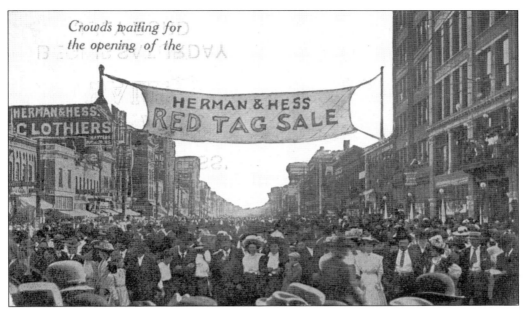

David Herman and Samuel Hess began selling clothing in 1885 at 406 East Douglas Avenue. They initially called their business the Manhattan Clothing Company, capitalizing on the name of the new Manhattan Hotel nearby. The store moved into the Bitting Block in 1898 and was there until 1911. This postcard promoted their Red Tag Sale on July 23, 1910, with a banner attached to their roof superimposed on a photograph of a crowded street.

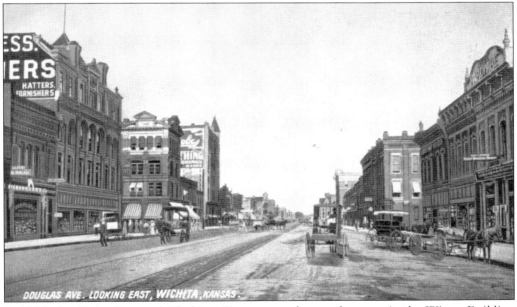

In 1906, the Globe Shoe and Clothing Company took over the space in the Winne Building where the Fulton Clothing Store formerly was, on the north side of Douglas Avenue midway between Market Street and Broadway. The large sign painted on the west side of the building changed then also. The sign atop the building on the far right marks the hardware store built by Jacob Bissantz at 123 East Douglas Avenue in 1879.

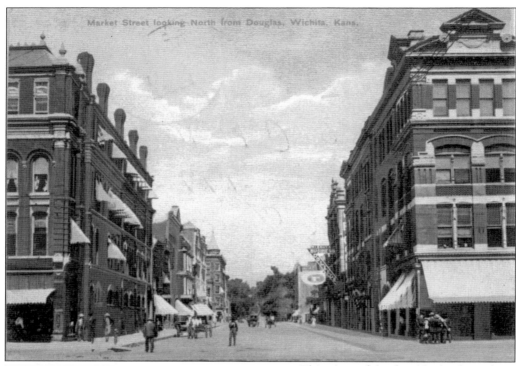

Market Street looking North from Douglas, Wichita, Kans.

This view of the first block of North Market Street is from around 1908. The sign of the Wichita Business College is prominently displayed on the east side of the street. On the left is the Bitting Block, with the five chimneys atop the east wall. The trees arching over the street just two blocks in the distance show how close the residential area was to downtown at the time.

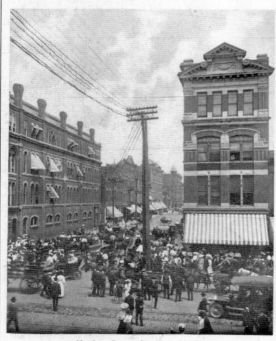

Market Street Looking North

This card also shows the 100 block of North Market Street around 1908, with a good view of the tall, narrow Fechheimer Block on the northeast corner of the intersection. Completed in 1887, it was the home of the Fourth National Bank from 1888 until 1915, when the bank constructed a new building on the site that is still present. Only one automobile is seen among all the horse-drawn wagons on the streets.

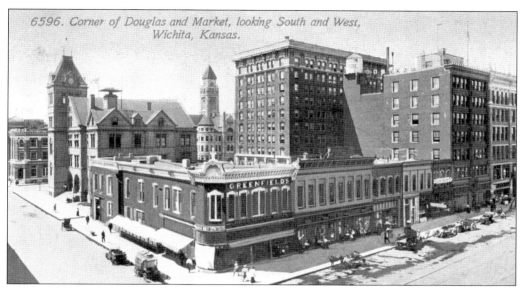

6596. Corner of Douglas and Market, looking South and West, Wichita, Kansas.

The photographer who captured this image was on top of the Fechheimer Block looking southwest. It shows how the south side of the 100 block of East Douglas Avenue looked around 1913. Greenfield's clothing store inhabited the corner building from 1902 to 1922, when the store closed and the building was demolished. It was replaced by the Woolf Brothers Building, which still stands.

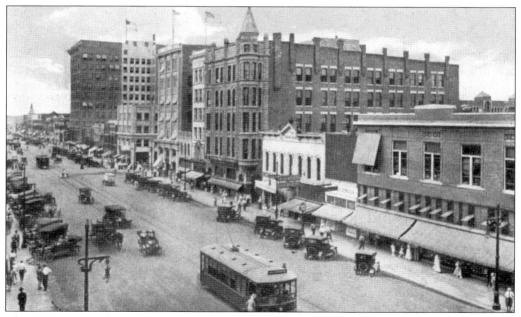

This 1918 postcard shows the north side of the 200 block of East Douglas Avenue, with the Winne Building prominently occupying the middle of the block. A new-model streetcar is in the foreground, and farther west is a pre-1900 model. Only one horse-drawn wagon is visible, while numerous automobiles line the curbing. By 1921, only three percent of Wichita's vehicles were horse-drawn as cars and trucks rapidly replaced them. Within two decades, the streetcars would be gone as well.

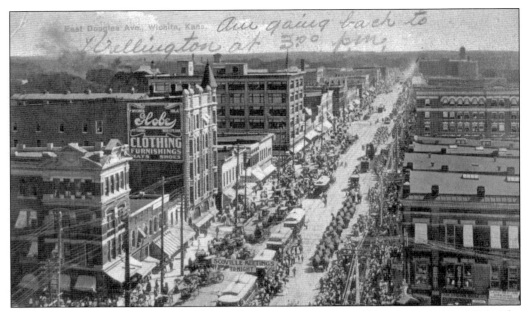

This card was mailed on July 2, 1911, and the image was most likely recorded in 1910. The view looks east down Douglas Avenue from the top of the Caldwell-Murdock Building. A large circus paraded through downtown, with 25 elephants in the procession. Both sides of the street are packed with spectators. The banner hung across the street advertised a religious revival featuring Charles Scoville, a noted evangelist of the time.

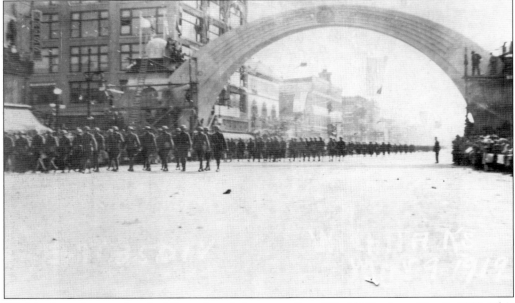

Wichita hosted a parade of soldiers after their return from World War I on May 9, 1919. This real-photo postcard shows the parade passing beneath the Victory Arch, built across Douglas Avenue at Broadway just prior to the parade. The arch was located in the middle of Broadway, and people began objecting to it as an impediment to traffic a few months later. It was torn down in August 1920.

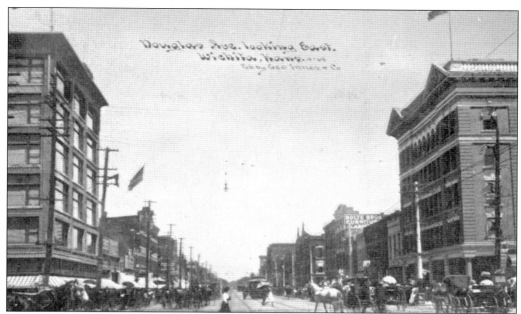

Henry Bolte began the Bolte Furniture and Carpet Company in 1870. In 1905, his sons built a three-story building for the business at 323–325 East Douglas Avenue. Their sign is visible on the upper west wall of that building in this view looking east on Douglas Avenue from Broadway. They liquidated the firm only four years later and went into real estate instead. The Kansas Health Foundation parking lot occupies the site now.

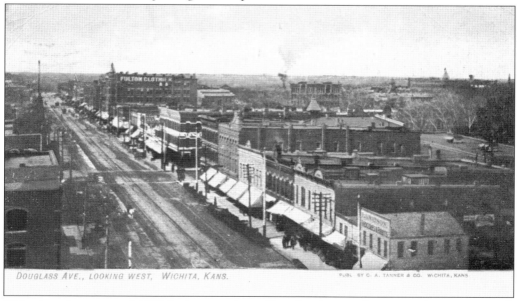

This view from around 1905 looks west down Douglas Avenue from atop the Carey Hotel. A sign for the Fulton Clothing Store is on the upper wall of the Winne Building, the tallest building on the north side of Douglas Avenue at the time. Lorrie Watson's grocery store occupies the northwest corner of Douglas and Emporia Avenues in the right foreground, currently the location of Mead's Corner Coffee Shop.

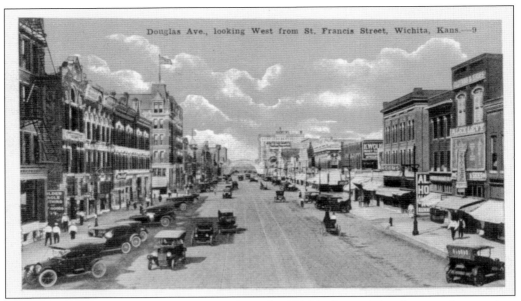

This view looks west on Douglas Avenue from the 600 block east. The photograph was taken from the railroad overpass. The Victory Arch is visible in the distance, dating the image to between May 1919 and August 1920. Most of the buildings in the right foreground are still present, but all of the buildings opposite them were demolished in 1977–1978 for the creation of Naftzger Memorial Park.

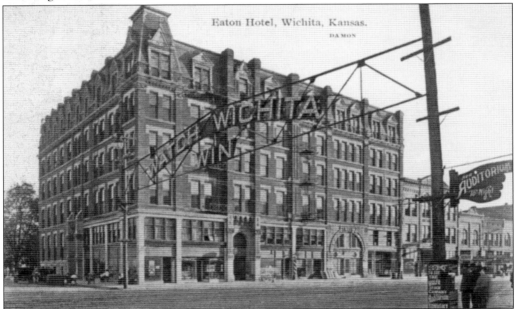

"Watch Wichita Win" was a new slogan adopted by local boosters in 1909. A sign bearing the slogan was placed across East Douglas Avenue in front of the Carey Hotel, where it was sure to be seen by people arriving by train. The sign was illuminated every evening until midnight by blinking electric light bulbs. It was removed on August 25, 1914. Henry B. Damon created this and many other Wichita postcards. (Courtesy Hal Ottaway.)

Two

DOWNTOWN BUILDINGS

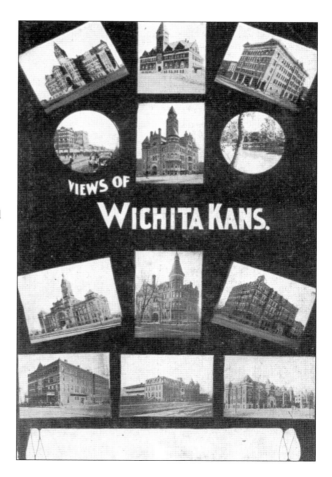

Most multi-view postcards included three or four illustrations at most, but this one includes 12, almost requiring a magnifying glass to discern what is shown. This overwrought quality echoes the overreaching that occurred in Wichita's boom years. From left to right and top to bottom are Garfield Hall at Friends University, Fairmount College, the Barnes Block, a Douglas Avenue view, city hall, a view along the Little Arkansas River, the county courthouse, the Scottish Rite Temple, the Carey and Hamilton Hotels, St. Francis Hospital, and Mt. Carmel Academy.

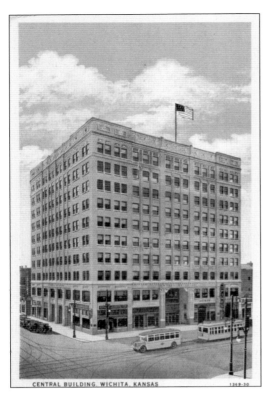

CENTRAL BUILDING, WICHITA, KANSAS 1369-30

The 10-story Central Building at the southwest corner of Main Street and Douglas Avenue was completed in 1929, just before the Great Depression. The first dividend to stockholders of the building was not paid until 1955. Spines Clothing Store was the first tenant in the new building and remained there until it closed in 1959. The Central Building was completely remodeled in 1969 and renamed Century Plaza. (Courtesy Jeff Roth.)

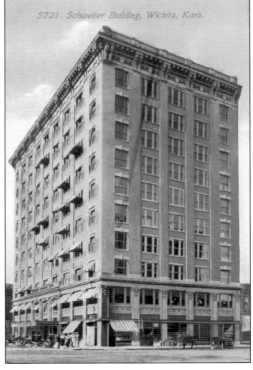

Henry Schweiter came to Wichita in the early 1870s, prospering as a builder and developer. He had land southeast of downtown near Chisholm Creek and sold ice cut from the creek. He constructed several buildings downtown, the largest being the 10-story building on the northeast corner of Douglas Avenue and Main Street known as the Schweiter Building, completed in 1911. A postcard shop was on the first floor, just inside the main entrance.

The 10-story First National Bank Building at the northwest corner of Douglas Avenue and Main Street was completed in 1922, replacing the 1884 Citizen's Bank Building. The Kansas National Bank had absorbed the Citizen's Bank in 1895 and taken over the building. It combined with the National Bank of Commerce to form the First National Bank, Kansas's largest local bank, which was renamed Intrust Bank in 1993.

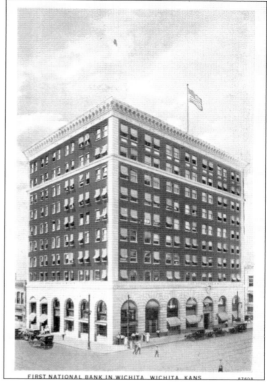

FIRST NATIONAL BANK IN WICHITA. WICHITA, KANS.

This hanging advertisement was for a brand of ham produced by the local Dold packing plant. These sorts of advertising signs were not uncommon at the time; the Boston Store had its name facing northeast on its roof in six-foot-tall letters that were brightly lit after dark, and the Lassen Hotel also had a large electric sign facing southeast on its roof.

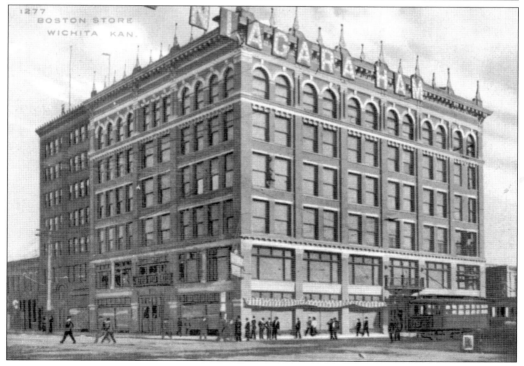

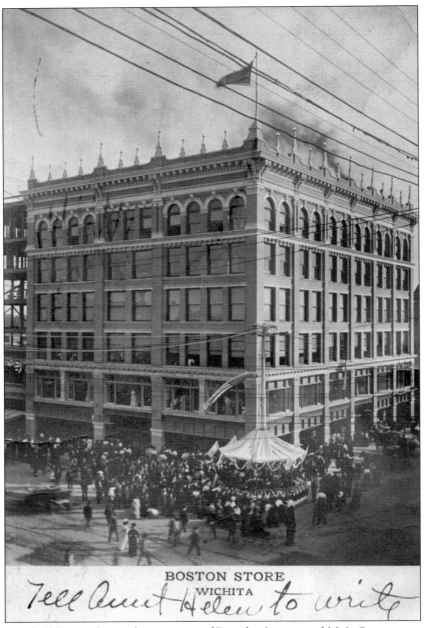

BOSTON STORE
WICHITA

Tell Aunt Helen to write

The six-story building at the southeast corner of Douglas Avenue and Main Street was originally a dry goods firm known as the Boston Store. This real-photo postcard shows the festivities at the grand opening on October 19, 1907. The steel beams of the adjacent Caldwell-Murdock Building, then under construction, are on the left. Previously, a two-story brick and stone building dating to 1871 had been on the corner. It was known as the Eagle Block because the *Wichita Eagle* newspaper was located within it. In 1915, Allen Hinkel was hired as manager of the Boston Store. He was very successful and purchased the business in 1924. It was called Hinkels from then until 1956, when it closed. For several years after, it was used for city government offices, and it became a private office building in 1980.

The *Wichita Eagle* and the *Wichita Beacon* both began in 1872. For the next 88 years, Wichita was a two-newspaper town. The *Beacon* was the evening paper and usually had more photographs. Their rivalry ended when the *Eagle* bought the *Beacon* in 1960. However, the *Beacon* outshone the *Eagle* when it built its new home in 1910, erecting this 10-story building that still stands at 114 South Main Street.

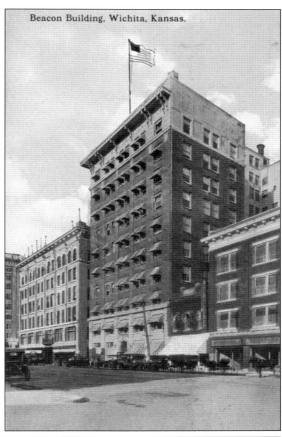

Beacon Building, Wichita, Kansas.

The Coronado Club formed in September 1890 as a social club for downtown businessmen. In January 1896, it transformed into the Wichita Commercial Club and became more of a civic booster organization. It bought the northeast corner of First and Market Streets in 1908 and completed its new building in 1911, which it kept until 1938. This is currently an office building, and the club itself has dwindled away.

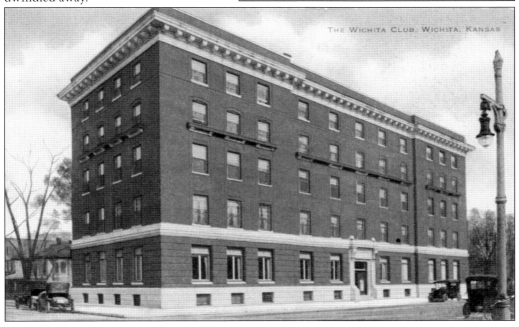

THE WICHITA CLUB, WICHITA, KANSAS

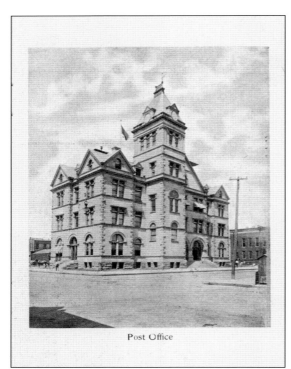

Post Office

The post office in Wichita was in different locations before moving into this new building on the northwest corner of Market and William Streets in August 1890. Its tower was a part of Wichita's downtown skyline until 1936, when the building was demolished. A clock was never installed in the tower. The weather bureau, federal court offices, and the court chambers were also in this building.

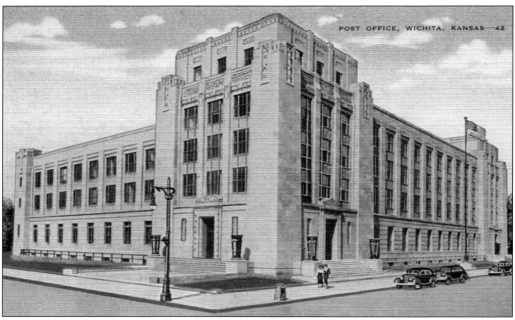

POST OFFICE, WICHITA, KANSAS—42

This view looks northeast at the federal building, completed in 1932 on the north side of Third Street between Main and Market Streets. The site was cleared in 1928, but construction did not begin until 1930. The lobby features two Public Works Administration murals completed in 1936. It now houses only the offices of the federal court and the court chambers. The post office moved to a new facility near the airport in 1977.

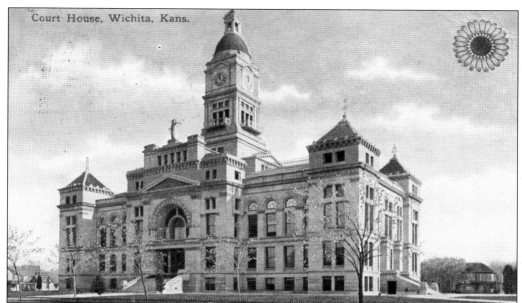

Court House, Wichita, Kans.

The old county courthouse was built in 1888–1890 on the north side of Central Avenue between Main and Market Streets. It no longer has the central clock tower, which was removed in 1954 after being badly damaged by a storm. The Howard clock went into storage, and its 5,010-pound bell is displayed near the southeast corner of the new courthouse across the street. The building was extensively refurbished in the 1970s.

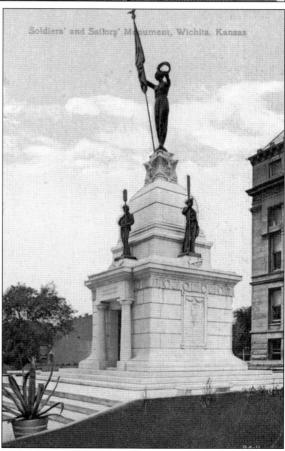

Soldiers' and Sailors' Monument, Wichita, Kansas

The Soldiers and Sailors Memorial, on the south side of the old county courthouse, was dedicated on June 14, 1913, in honor of the veterans of the Civil War. It was designed by sculptor Ernest Moore Viquesney, although its five human statues were made by other artists. Later, Viquesney created the famous *Spirit of the American Doughboy* statue found in many World War I memorials nationwide.

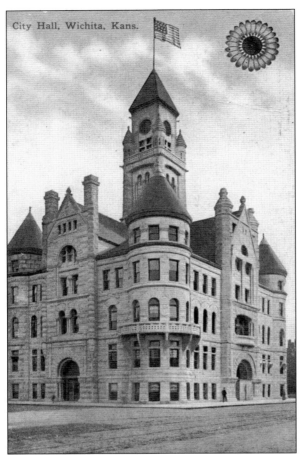

City Hall, Wichita, Kans.

Wichita's old city hall, designed by local architects Proudfoot and Bird and built in 1890–1892 at the southeast corner of William and Main Streets, served as the seat of local government for more than 70 years. The tower did not have a clock until 1917, when a Seth Thomas clock was finally installed. The building today houses the Wichita/Sedgwick County Historical Museum.

This view looks north on Main Street towards Wichita's Carnegie Library, built just south of city hall between 1913 and 1915. It served for 51 years until the new Central Library was built across the street. A team of 600 public school students formed a "book brigade" and moved 20,000 books to the new library on January 29, 1967. The old library building was bought by Fidelity Bank in 2006.

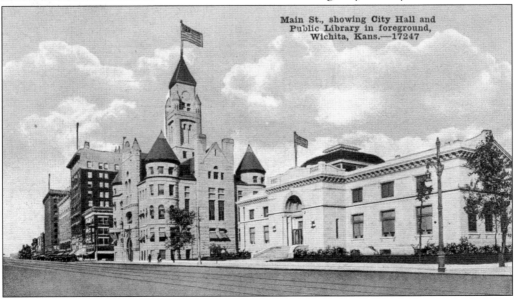

Main St., showing City Hall and Public Library in foreground, Wichita, Kans.—17247

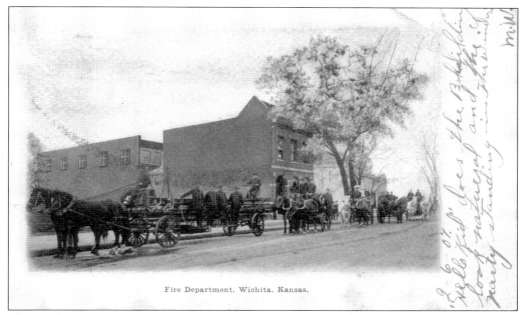

Fire Department. Wichita, Kansas.

The Wichita Fire Department was organized in 1886. By 1906, it had 31 men and 18 horses. This card shows the men and equipment of the two downtown fire stations that year. There was also a third station in Wichita's north end at Eighteenth Street and Topeka Avenue and a fourth in west Wichita at 112 South Seneca Street, which still exists.

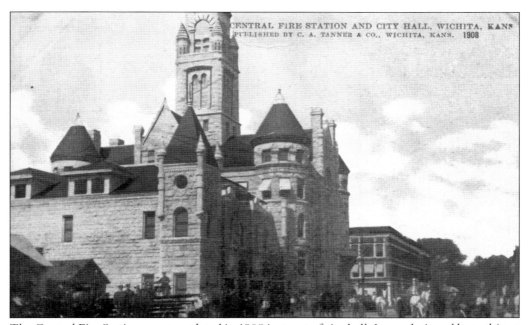

CENTRAL FIRE STATION AND CITY HALL, WICHITA, KANS
PUBLISHED BY C. A. TANNER & CO., WICHITA, KANS. 1908

The Central Fire Station was completed in 1908 just east of city hall. It was designed by architect John J. Crist to match the style of city hall. The fire department was still using horse-drawn equipment at the time but switched to trucks in 1914. The building was converted to a jail and police station in 1934. It was razed in 1976, and Heritage Square Park now occupies the site.

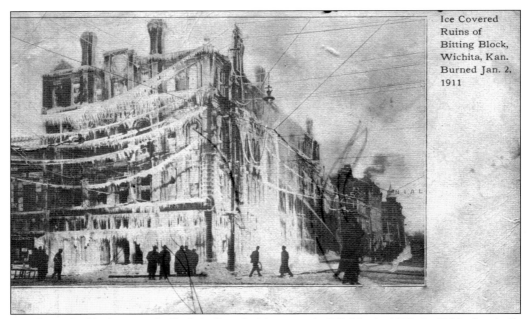

Ice Covered
Ruins of
Bitting Block,
Wichita, Kan.
Burned Jan. 2,
1911

Charles and Alfred Bitting built their first clothing store in Wichita in 1878. In 1888, they built the Bitting Block at the northwest corner of Douglas Avenue and Market Street and moved their store into the ground floor. In 1898, they sold their clothing business to Herman and Hess. The Bitting Block was gutted by fire on January 2, 1911. This card was mailed 10 days later.

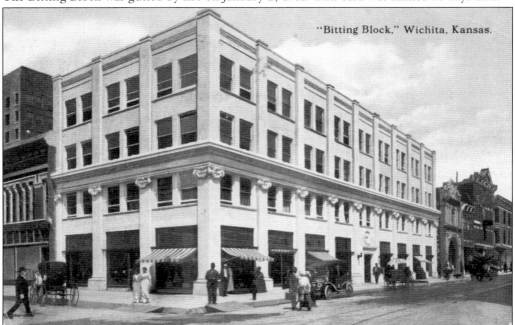

"Bitting Block," Wichita, Kansas.

The Bitting Block was promptly rebuilt after the fire but only to the four-story size seen here. The intention was to build to 11 stories, but that did not happen until 1918. At that time, permission for the construction had to be sought from the federal government because of materials shortages during World War I. The building still stands.

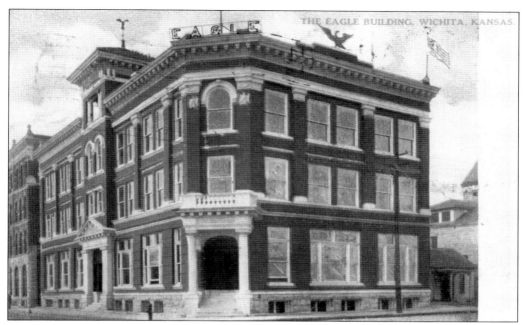

The *Wichita Eagle* newspaper erected this building in 1907 on the southwest corner of Market and William Streets. When the newspaper moved to its current location on East Douglas Avenue in 1961, this building and some adjacent structures were replaced with a parking garage for the Innes Store, located diagonally northeast across the intersection. The eagle statues on the roof were formerly on the Eagle Block at Douglas Avenue and Main Street.

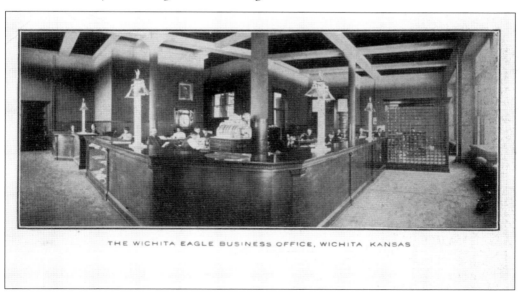

This elegantly styled lobby greeted customers as they came into the Eagle Building via the corner entrance to place an advertisement, speak to a reporter, buttonhole the editor, or conduct other business. Several staff members are busy at their desks, and a portrait photograph of Marshall Murdock, the newspaper's founder, hangs on the far wall. A massive 500-Series National cash register looms behind the front counter.

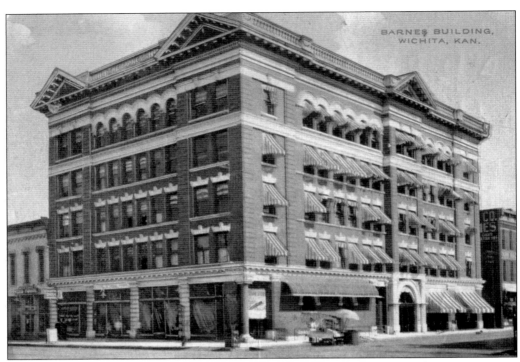

BARNES BUILDING, WICHITA, KAN.

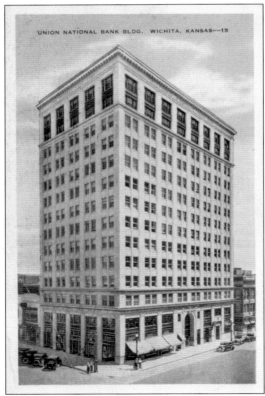

UNION NATIONAL BANK BLDG. WICHITA, KANSAS—15

The Barnes Block was built in 1906 on the southeast corner of Douglas Avenue and Broadway, replacing a wood-frame building that had stood there since 1875. Oscar D. Barnes came to Wichita in 1879 and became a successful druggist, later growing wealthy through real estate investments. The canvas awnings on the west side of the building were common on downtown businesses in the decades before air-conditioning.

The Union State Bank occupied the first floor of the Barnes Block in 1914 and bought it outright in 1917 just before becoming the Union National Bank. The bank razed the building in 1925, replacing it with the 14-story Union National Bank Building, which still stands. After many decades as a downtown office building, it sat vacant in recent years. It was remodeled in 2011–2012 to become the Ambassador Hotel.

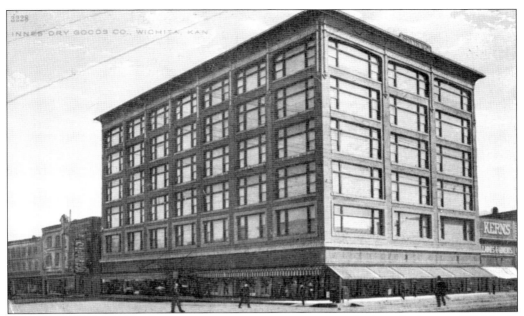

George Innes was a dry goods merchant in Lawrence, Kansas, who branched out to Wichita in 1876, initially working in partnership with Finlay Ross at 120 North Main Street. When the Smyth Block was built on the northeast corner of Douglas Avenue and Broadway in 1908, its first tenant was the new Innes Store. On May 5, 1916, the Innes Tea Room was opened.

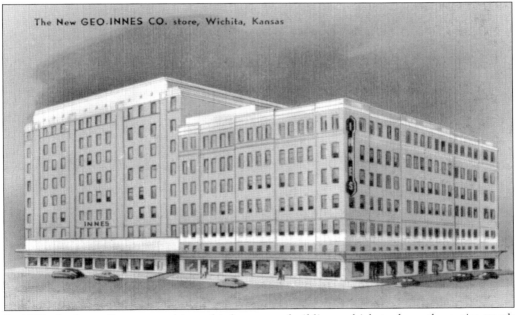

In 1927, the Innes Store moved into this large new building, which took up the entire north side of the 200 block of East William Street. It had the first escalators in Kansas and was purchased by Macy's in 1955 before becoming a Dillard's in 1988. The Innes Tea Room closed in December 1972. The building was converted to the Finney State Office Building in 1994. (Courtesy Jeff Roth.)

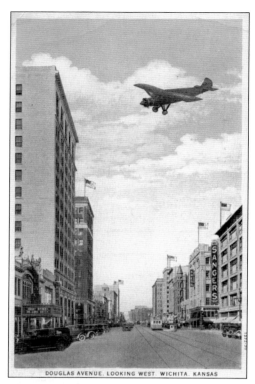

DOUGLAS AVENUE, LOOKING WEST, WICHITA, KANSAS

In 1928, Sanger's moved into the old Innes Store on Douglas Avenue. It went out of business in December 1930, and Rorabaugh Dry Goods moved in afterwards. On the left, the Palace Theater marquee advertises *So Long Letty*, which premiered in October 1929, the month of the stock market crash. The airplane added to the sky was a Travel Air, made in Wichita.

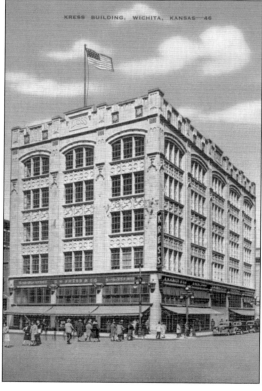

KRESS BUILDING, WICHITA, KANSAS—46

S.H. Kress & Co., a nationwide five and dime chain, opened a store at 123 East Douglas Avenue in 1906. It built a new two-story building at the northwest corner of Broadway and Douglas Avenue in 1913. Later, it replaced that building with this five-story Commercial Gothic structure, which opened January 8, 1930. The Kress store closed in 1974, and the building is now used for office space.

Wichita Lodge No. 427 of the Benevolent and Protective Order of Elks bought this building at 115–117 North Topeka Avenue, using a room in it for their meeting place from 1906 to 1925. Samuel B. Amidon, a prominent local attorney, sponsored an annual charity Christmas dinner usually held there. The mounted elk head on the second-floor corner of the building is a feature commonly seen on Elk's Lodge buildings.

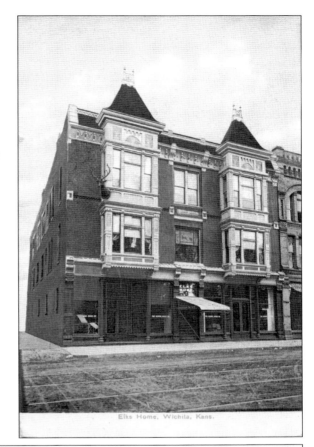

Elks Home, Wichita, Kans.

Ed Forsblom designed this five-story building for the Wichita Elks Lodge, complete with an indoor swimming pool and gymnasium. It was built in 1923-1925 on the east side of North Market Street, just north of and adjacent to the Wichita Club building. Both buildings were purchased by Farmers and Bankers Life Insurance Company in 1946. Signs advertising the company still adorn both buildings.

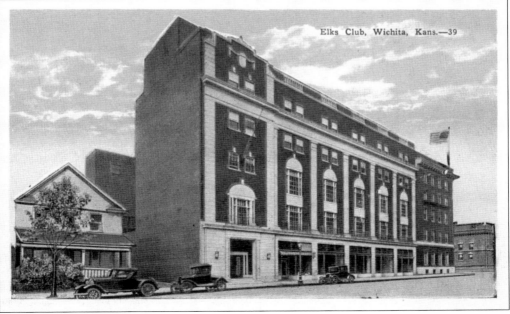

Elks Club, Wichita, Kans.—39

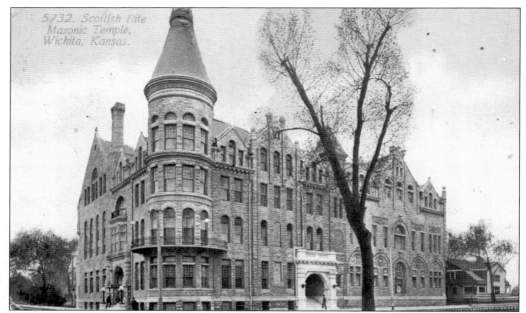

This Scottish Rite Temple was built in 1888 as a YMCA on the northwest corner of First Street and Topeka Avenue. Proudfoot and Bird were the architects. As the boom collapsed, so did the prospects for the YMCA. After attempts to refinance the building failed, it was sold to the Scottish Rite Masons in 1898. The original building (see page 117) was enlarged in 1908 to the size shown here.

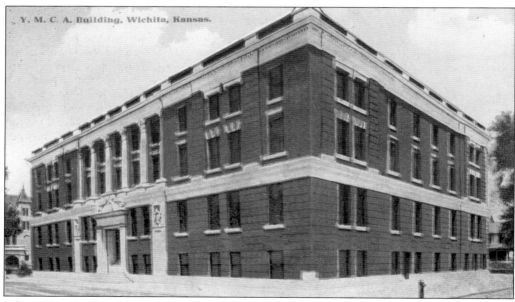

After selling its first building, the downtown YMCA was temporarily housed on the second floor of the Morris Block at 213 North Main Street. This new YMCA was eventually built on the northwest corner of First Street and Emporia Avenue. It opened in August 1908 and was the downtown YMCA until 1959, when a new facility was constructed at 402 North Market Street. This building was razed three years later.

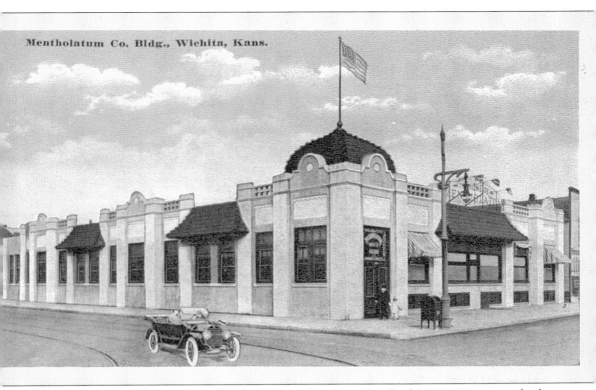

Mentholatum Co. Bldg., Wichita, Kans.

Albert Alexander Hyde came to Wichita in 1872 and was involved in many ventures both financial and philanthropic. By turns a banker, bookseller, and real estate developer, he ultimately made his fortune from a salve he invented in 1894 called Mentholatum. The Mission-style Mentholatum Building at the northeast corner of Douglas and Cleveland Avenues was the factory where it was made for many years. It was built in 1909 and designed by Ulysses Grant Charles. Hyde helped establish and support both the YMCA and YWCA and donated four acres of land in 1884 for Wichita's first public park, which bears his name. He also helped develop Maple Grove Cemetery, on the east side of North Hillside Avenue across from Highland Cemetery. He lived in Wichita until his death in January 1935. Since 1984, the Mentholatum Building has been occupied by the Spice Merchant & Company, a specialty food and gift retailer. (Courtesy Hal Ottaway.)

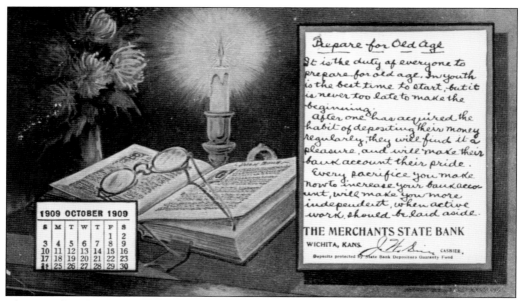

The Merchant's State Bank was located in the Lawrence Block on the southeast corner of Douglas and Emporia Avenues. It sent out these unusual advertising cards in October 1909 with an apparently handwritten note from the bank's cashier, Jerry W. Dice, advising that regular deposits will help prepare for old age. The addressee was Edmund K. Nevling, the owner of a large grain elevator.

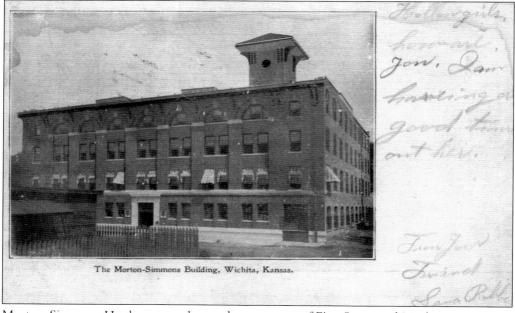

The Morton-Simmons Building, Wichita, Kansas.

Morton–Simmons Hardware, on the northwest corner of First Street and Mosley Avenue, was built in 1905. It was long known as the Keen Kutter Building because of Morton-Simmons's Keen Kutter emblem painted on the tower. The hardware firm failed in the 1930s, and the building was used as a warehouse for several years afterwards. In 1999, the building was renovated and transformed into The Hotel at Old Town.

Three

DEPOTS AND HOTELS

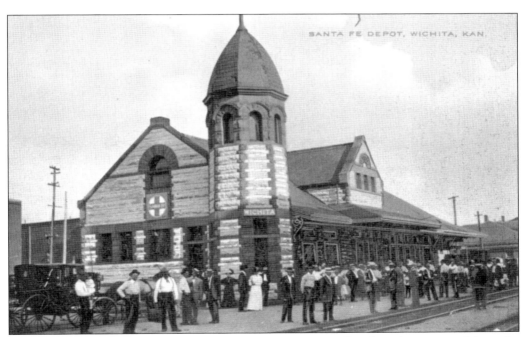

SANTA FE DEPOT, WICHITA, KAN.

The first railroad came to Wichita in 1872. It was a spur line later incorporated into the Atchison, Topeka & Santa Fe Railroad. However, the line never had a substantial passenger depot until this was erected in 1889–1890 on the south side of Douglas Avenue six blocks east of Main Street. This view looks southeast. The depot was razed in 1913 when the Union Station was built.

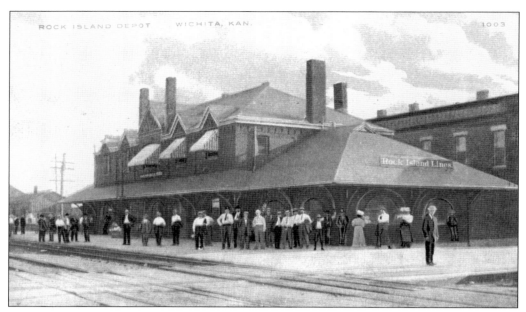

To ensure the success of the town, Wichita's community leaders worked hard to attract railroads, and they had four by 1892. This view looks southwest at the Rock Island passenger depot, built in 1887 on the southwest corner of Douglas and Mead Avenues, seven blocks east of Main Street. It is the only one of the individual depots still in existence. It has housed restaurants in recent years and is a landmark in Wichita's Old Town District.

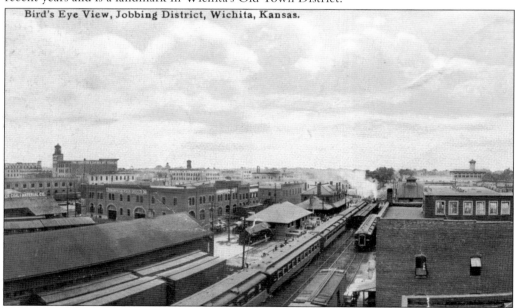

Bird's Eye View, Jobbing District, Wichita, Kansas.

This card shows a busy day at the Rock Island depot, seen here from the top of the Hockaday Hardware warehouse one block southeast of the depot. In 1900, there were 26 passenger trains in and out of Wichita every day. Numerous freight trains were also plying the rails through town serving the bustling warehouse district that grew up around the depots on east Douglas Avenue.

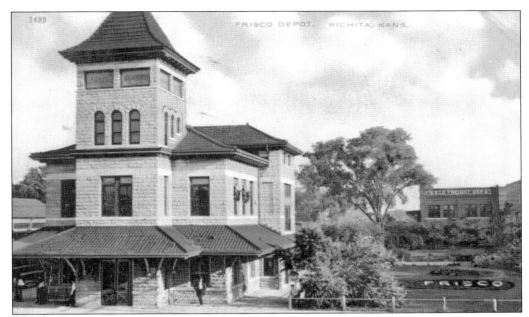

The St. Louis & San Francisco (Frisco) passenger depot opened on August 1, 1903, at the southwest corner of Douglas and Mosley Avenues. This view looks southeast. It was superseded just a few years later by the Union Station and was abandoned by 1914. It was a Salvation Army "Soldiers and Sailors Club" in 1919–1920 and was gone by 1950. The *Wichita Eagle* occupies this site now.

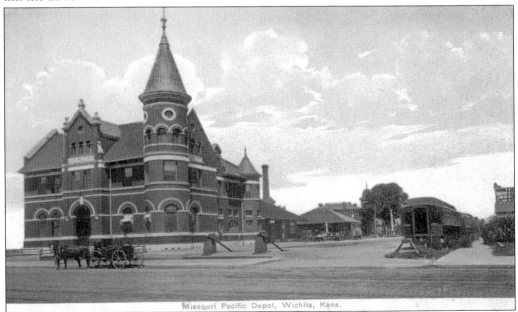

The Missouri Pacific passenger depot opened on January 1, 1901, at 300 West Douglas Avenue, where the R.H. Garvey Building is today. Other than the Rock Island depot, it was the last of the individual passenger depots to survive. Its distinctive spire was a landmark west of downtown until 1964, when it was cleared away in the urban renewal efforts of that decade.

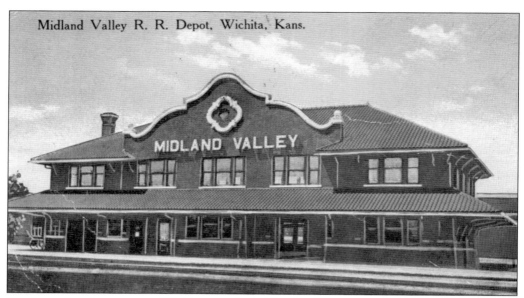

Midland Valley R. R. Depot, Wichita, Kans.

MIDLAND VALLEY

The last railroad to come to Wichita was the Midland Valley. Its Mission-style passenger depot was on the west side of the Arkansas River, south of Douglas Avenue. It was designed by local architect Ulysses Grant Charles and opened on October 4, 1911. This view looks west. Passenger service here ended in 1931. Both this and the adjacent freight depot were demolished in 1964 in preparation for the construction of the Metropolitan Baptist Church.

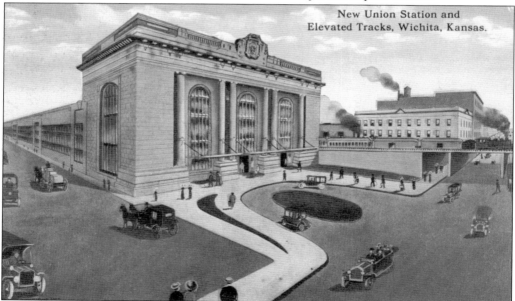

New Union Station and Elevated Tracks, Wichita, Kansas.

Most passenger rail service in Wichita was consolidated in the Union Station, which was built from 1911 to 1914. At the same time, the railroad tracks were elevated through downtown between Central Avenue and Kellogg Street to help eliminate conflicts between trains and crosstown vehicular traffic. Numerous buildings were cleared to enable all this construction, including the Santa Fe depot. Over 300,000 cubic yards of sand was dredged from the Arkansas River to make the fill for the elevated tracks.

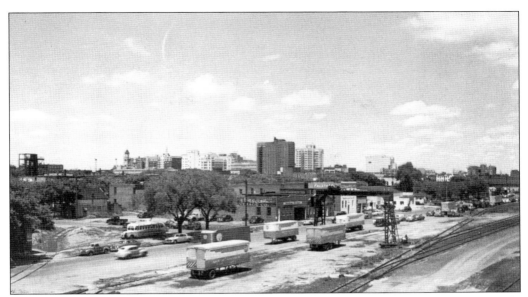

A third part of the Union Station project was elevating Kellogg Street over the railroad tracks between Washington and Emporia Avenues, making the first Kellogg viaduct. On the north, the tracks continued to cross Central Avenue at grade for another 90 years. This view from the 1940s looks northwest towards downtown from the viaduct. The Intrust Bank Arena, which opened in January 2010, currently occupies an entire city block in the center of this scene.

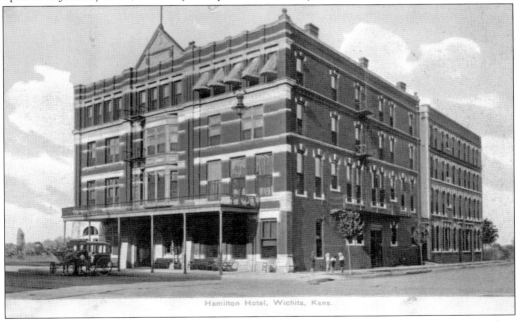

Hamilton Hotel, Wichita, Kans.

The Hamilton Hotel was at the northeast corner of Main and English Streets. In 1886, Milton Stewart built a two-story brick building there called the Caldwell House, which he expanded to four stories in 1889 and renamed the Hotel Metropole. It was expanded to this size and renamed again as the Hamilton after J.Q. Hamilton purchased it in 1900. The building was demolished in 1959, and Fidelity Bank occupies the site now.

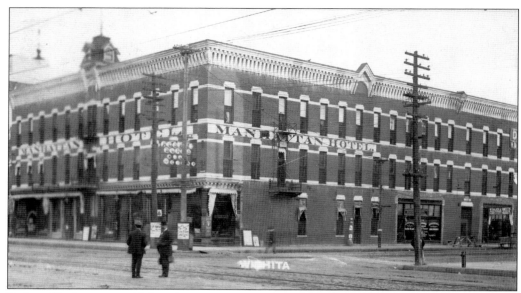

Robert Black came to Wichita from Warsaw, Illinois, in 1884 and built the 70-room Manhattan Hotel on the northwest corner of Douglas and Topeka Avenues, seen here in a real-photo postcard postmarked in 1911. Black died in 1894, and the building went through many changes afterwards. The ground floor was converted to a bank and office space in the 1920s. The building was razed in 1972 during construction of the Fourth Financial Center (now the Bank of America Center).

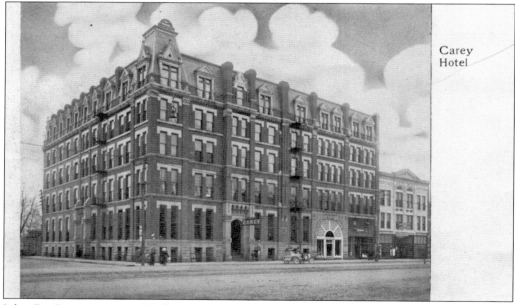

Carey Hotel

John B. Carey came to Wichita in 1874 and prospered as a lumber dealer and real estate developer. He built the 130-room Carey Hotel on the southwest corner of Douglas and St. Francis Avenues, and it opened in January 1888. Perhaps the most famous event to occur here was the trashing of the saloon by the militant temperance crusader Carry A. Nation on December 27, 1900. Her act inspired many similar assaults on taverns elsewhere.

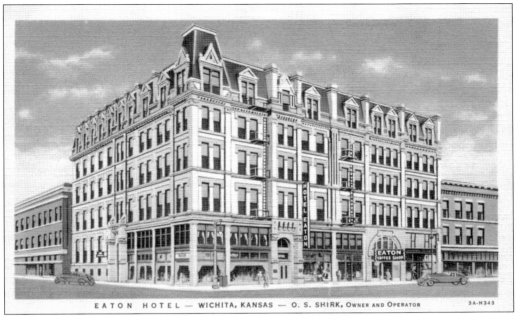

EATON HOTEL — WICHITA, KANSAS — O. S. SHIRK, Owner and Operator 3A-H343

Benjamin L. Eaton began operating the Carey Hotel in 1894 and bought it in 1899, after the death of John Carey. Eaton completely remodeled the hotel in 1909, and it was renamed for him. Oscar Shirk bought the hotel in 1915. The entire block was bought by the city in 1998, and the hotel was converted into the Eaton Place apartments.

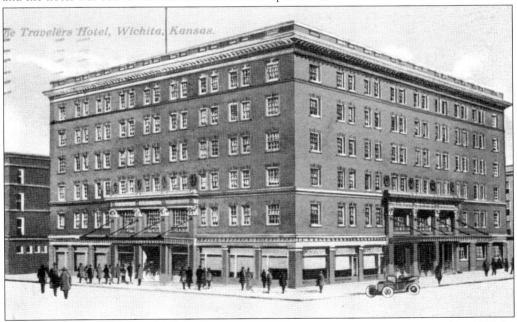

This postcard shows a hotel that was never built. The Travelers Hotel was proposed in 1912 for the southwest corner of First and Market Streets, but instead, the Lassen Hotel was built there in 1918. The name was changed when Henry Lassen joined the group of hotel developers. Lassen died of a heart attack at the age of 57, two days after the hotel opened on January 1, 1919.

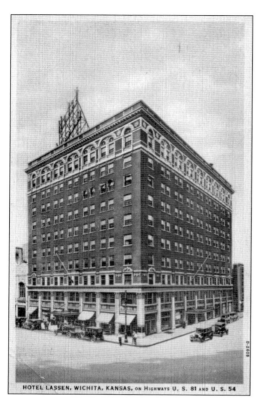

HOTEL LASSEN, WICHITA, KANSAS, on Highways U. S. 81 and U. S. 54

The Lassen Hotel is on the southwest corner of First and Market Streets. This is the same corner where the Turner Opera House, one of Wichita's first auditoriums, was built in 1879. The Lassen housed radio station KFH from 1925 to 1929—the call letters stood for "Kansas' Finest Hotel"—and was the original home of the Petroleum Club in 1949. The hotel was converted to an office building in the 1980s.

The 17-story Allis Hotel was the tallest building in Kansas when it opened in 1930 at the southeast corner of Broadway and William Street. At one time, both TWA and Braniff Airways had ticket offices there. The sender of this card marked the penthouse room where she stayed in 1949. The hotel closed in 1970 and was demolished by controlled implosion on December 23, 1996. A parking lot occupies the site now.

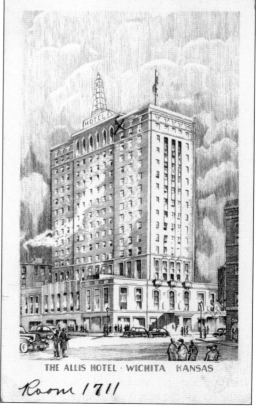

THE ALLIS HOTEL · WICHITA KANSAS

Room 1711

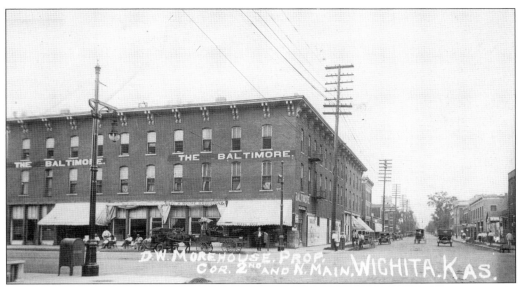

The Occidental Hotel was the pride of the city when it opened on January 15, 1874, at the northeast corner of Main and Second Streets. It was renamed the Baltimore Hotel in 1899, a name it kept until it closed in 1975. It was renovated afterwards and is used for office space now. The renovation included rebuilding an arcade-style balcony along the west side, missing in this 1915 real-photo postcard. It is the oldest building still standing in downtown Wichita. (Courtesy Wichita/Sedgwick County Historical Museum.)

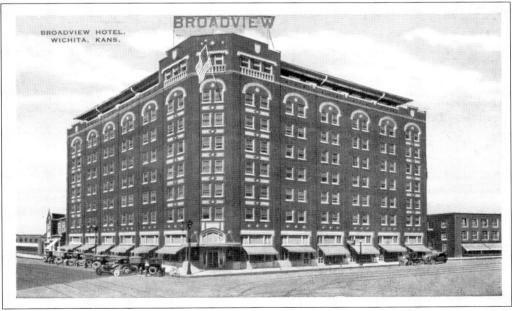

The Broadview Hotel opened on May 15, 1922, at the northwest corner of Douglas and Waco Avenues, which had previously been a site of horse stables and livery operations. The hotel's construction was promoted by the Arkansas Valley Interurban railroad (AVI). The railroad's Wichita terminus was on the west side of the hotel—the depot is the low building immediately to the left of the hotel.

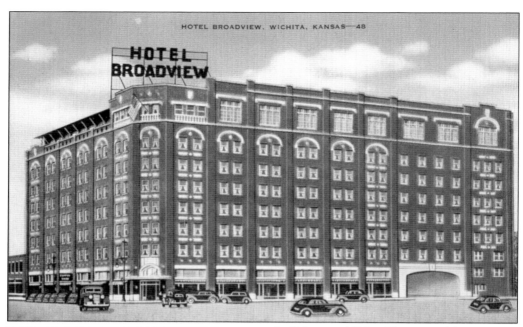

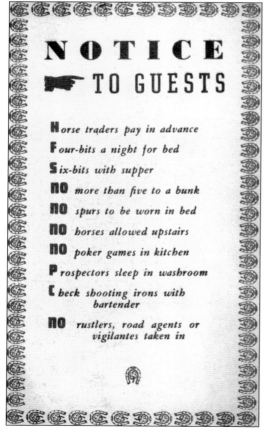

NOTICE
☛ TO GUESTS

Horse traders pay in advance

Four-bits a night for bed

Six-bits with supper

NO more than five to a bunk

NO spurs to be worn in bed

NO horses allowed upstairs

NO poker games in kitchen

Prospectors sleep in washroom

Check shooting irons with bartender

NO rustlers, road agents or vigilantes taken in

In February 1929, a 78-room addition was completed on the north side of the Broadview, built around and over the freight depot of the AVI. The broad concrete arch near the right side of the building at street level is the freight depot entrance. The Broadview was renovated and reopened in 2011 as the Drury Plaza Broadview.

For many years, the Broadview produced promotional postcards with long text passages on them rather than images of the hotel. The text included anything from an Abraham Lincoln quotation to a humorous poem about a woman criticizing her husband's drunken behavior. This is an early one with a whimsical list of what different travelers might pay to stay in a hotel during Wichita's early days as a frontier town.

Four

RESIDENCES, CHURCHES, AND HOSPITALS

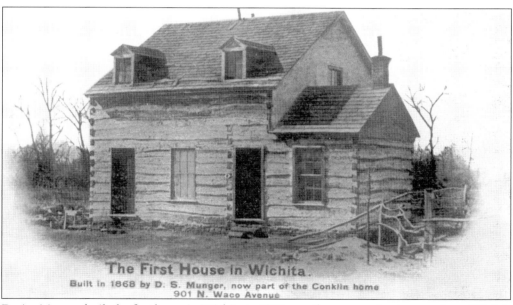

Darius Munger built the first home in Wichita in 1868 near the present-day intersection of Eighth Street and Waco Avenue. William C. Woodman acquired the structure in 1873 and added to it to create Lakeside, his home along the Little Arkansas River. In 1911, Lakeside was bought by Dr. John H. Fuller, who deconstructed it, revealing the Munger House once again. It sat for another 30 years before the local chapter of the Daughters of the American Revolution purchased it and donated it to Historic Wichita, Inc. It became one of the four founding structures of Wichita's Old Cowtown Museum, where it was restored and may be seen today.

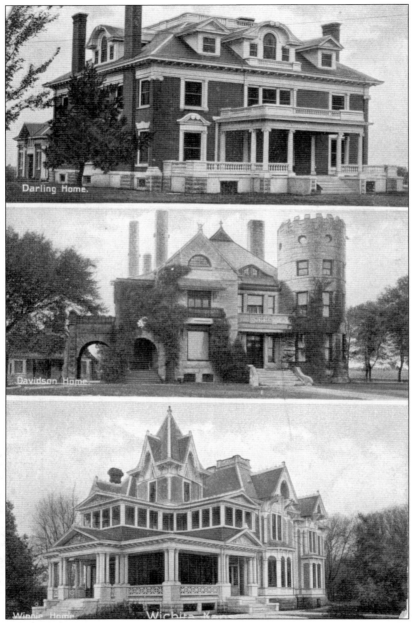

Two of the grand homes built in Wichita during the boom years of the late 1880s are featured on this card. At bottom is William Greiffenstein's mansion at Tenth Street and Jefferson Avenue, built in 1888. It was owned by Scott Winne from 1898 to 1908. This card was postmarked 1908; hence, it is called the Winne Home. In the middle is Burton Campbell's 1889 castle-like home at Eleventh Street and North River Boulevard, mistakenly identified here as the Davidson Home. On top is Howard W. Darling's home, built in the College Hill neighborhood at the southwest corner of Douglas and Roosevent Avenues in 1906. All look today much as they did then, with the exception of the Greiffenstein Mansion, which burned on July 28, 1932, and was only partially rebuilt afterwards.

The 1906 Darling home from the previous page is on the left, beside its two neighboring homes to the west. The other two homes were built in 1909—the near one for attorney Fred Stanley and the center one for Cyrus M. Beachy. At the time, Beachy was president of Steffen Dairy and vice president of Wichita Amusement Park Company, which owned Wonderland Park. All three dwellings are still standing. (Courtesy Jeff Roth.)

Wichita's College Hill neighborhood began to develop before World War I, but most of the homes were built in the two decades following the war. This card shows one of the large homes on North Belmont Avenue. The residents on this street sought further distinction by building elaborate archways in 1925 where their street intersects Central and Douglas Avenues. The arches were added to the National Register of Historic Places in 2007.

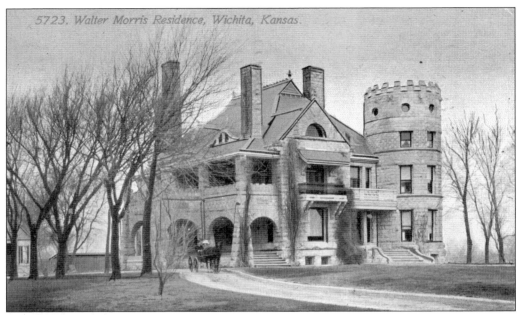

5723. Walter Morris Residence, Wichita, Kansas.

Burton "Barbecue" Campbell died on January 3, 1908, while returning from a train trip to Mexico. His "castle" at Eleventh Street and North River Boulevard was purchased in 1910 by Walter Morris, a prominent real estate developer. Subsequently, this postcard was created naming the residence as the Morris Home. Morris lived there until his death in 1951. The residence and the carriage house were converted to a bed-and-breakfast in 1994.

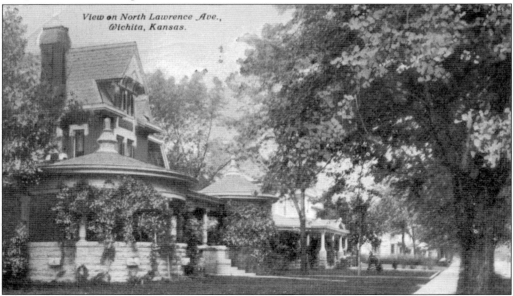

View on North Lawrence Ave., Wichita, Kansas.

One of the first upscale neighborhoods of Wichita was Midtown, located north of downtown to Thirteenth Street. Many grand residences were built there, and many still survive, but not this one. The Mark J. Oliver home was built on the northwest corner of Tenth Street and Broadway in 1886. It was a used furniture store when it was demolished in 1969. The Saigon Restaurant occupies the corner currently.

This dual-view card shows streets in two Wichita neighborhoods whose destinies changed. The Riverview neighborhood, shown in the upper half, was northwest of downtown. After going into decline, it was completely cleared during urban renewal. A large apartment complex occupies this site now. Both North and South Lawrence Avenue transformed into commercial strips after it became Highway 81. Lawrence Avenue was renamed Broadway in 1933.

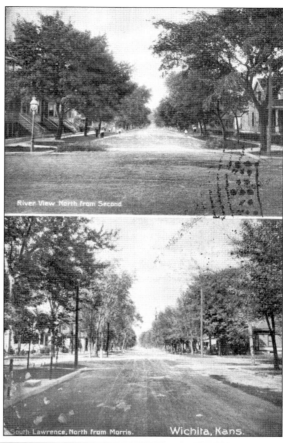

Robert E. Lawrence was a prominent resident of west Wichita. His mansion at the southwest corner of Maple and Seneca Streets was designed by Proudfoot and Bird and built in 1889. He sold it in 1896 to the Kansas Masonic Order, who made it into a group residence for children and the aged known as the Masonic Home. Children continued to live there until 1958. It is only a residence for the elderly now.

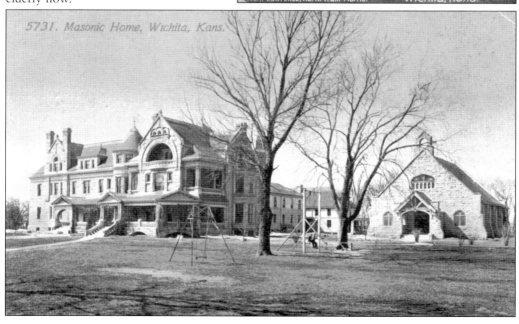

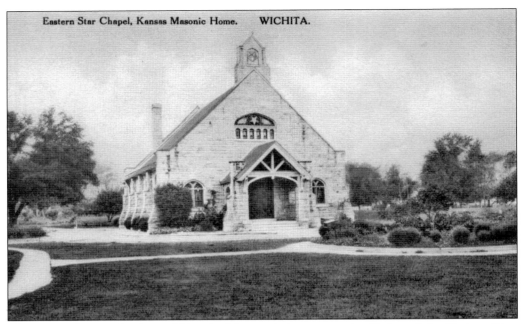

Eastern Star Chapel, Kansas Masonic Home. WICHITA.

The women's organization within the Masons is known as the Order of the Eastern Star. The Eastern Star Chapel on the grounds of the Masonic Home was built in 1906 a short distance northwest of the main building. The main building burned down on a cold night in December 1916, but the chapel survived the fire and still stands today as part of the Masonic Home campus.

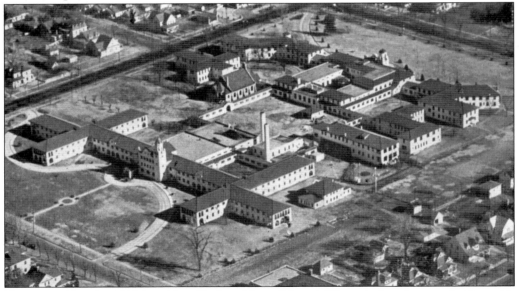

Two years after the 1916 fire, New York architect Edward Tilton designed a new facility with Spanish Mission–style architecture that opened in 1919. By the 1930s, when this aerial postcard view looking northeast was produced, the Masonic Home had expanded several times. The campus has been further enlarged and rebuilt in recent decades, but much of the facility seen here still remains.

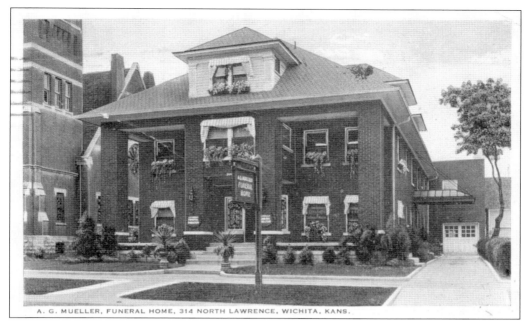

A. G. MUELLER, FUNERAL HOME, 314 NORTH LAWRENCE, WICHITA, KANS.

Alfred Mueller came to Wichita in 1888 and began an undertaking business. In 1920, he remodeled and enlarged a residence at 314 North Broadway into a funeral home. Mueller ran the business next door to the First Methodist Episcopal Church until he retired in 1936. The funeral home was later converted to apartments and was demolished by the church in 1959 to make way for its present building.

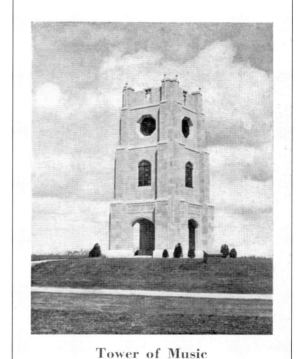

Tower of Music

MEMORIAL LAWNS CEMETERY
17th & Oliver
Wichita, Kansas

College Hill Memorial Lawns Cemetery began in 1918 on 80 acres northeast of Seventeenth Street and Oliver Avenue. This carillon was built there in 1931. At the time, it was the only one like it in the Western Hemisphere. It played summer evening concerts in years past but is no longer used. The cemetery became White Chapel Memorial Gardens in 1945.

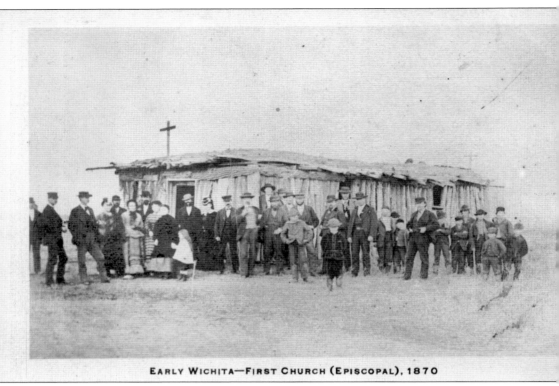

EARLY WICHITA—FIRST CHURCH (EPISCOPAL), 1870

The first church in Wichita was built in 1870 on the east side of Main Street between Third Street and Central Avenue, a block south of the old county courthouse. William Greiffenstein donated the land for the church as well as the building materials—split cottonwood logs and a sod roof. The logs had formerly been used in the stockade at Durfee's Trading Post, which was part of the original settlement near Eighth Street and Waco Avenue. Many Wichitans once owned a copy of this photograph, which was made into this real-photo postcard. The congregation that met here eventually formed the St. John's Episcopal Church.

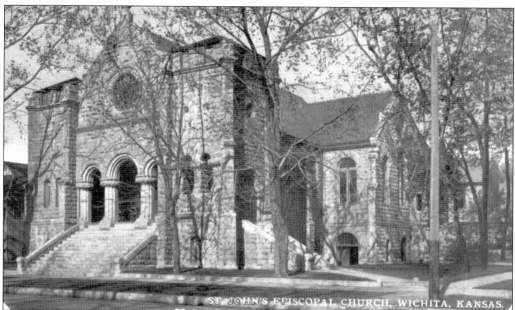

ST. JOHN'S EPISCOPAL CHURCH, WICHITA, KANSAS.

In the 1870s, St. John's Episcopal Church built a small frame church on North Broadway. Then, in 1887, the cornerstone of this Early Norman–style church was laid at the northeast corner of Third Street and Topeka Avenue, just as Wichita's real estate boom went bust. The church was not completed until a rector was able to raise funds from patrons in Boston and New York City in the 1890s.

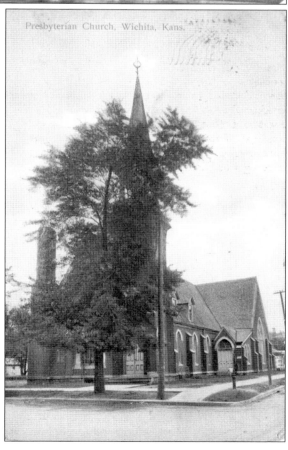

Presbyterian Church, Wichita, Kans.

The First Presbyterian Church in Wichita existed prior to the founding of the city, first meeting in March 1870 in a dugout house near Twelfth Street and Jackson Avenue that was also Wichita's first school. A frame church was built later that year at Second and Wichita Streets. This brick church was built at the southwest corner of Broadway and First Street in 1876.

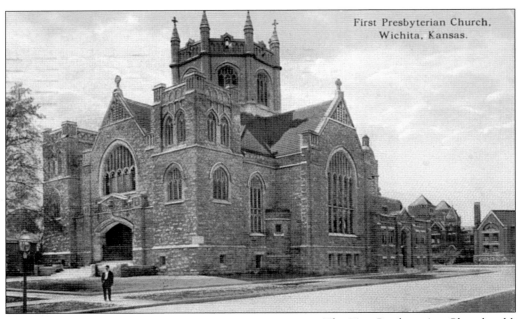

First Presbyterian Church, Wichita, Kansas.

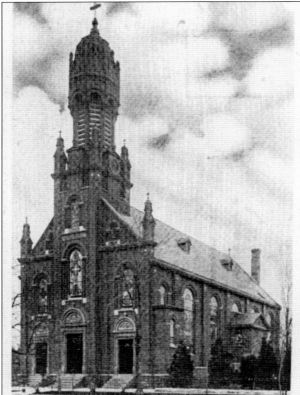

St. Anthony's German Cath. Church, Wichita Kans

The First Presbyterian Church sold its 1876 church in 1909 to John H. Butts, who built a five-story building on the site. The current church was completed in the spring of 1912 on the southwest corner of Broadway and Elm Street. The congregation met in the Lewis Academy building during construction. This view looks southwest with the old county courthouse and jail to the right of the church.

St. Anthony's Catholic Church was completed in 1905 at the southeast corner of Second Street and Ohio Avenue and was originally referred to as the German Catholic Church. Its distinctive belfry rises high above the trees in the neighborhood east of downtown. It replaced the St. Boniface Church, built in 1887 on the northeast corner of the intersection, where a church school was built in 1915. (Courtesy Wichita/Sedgwick County Historical Museum.)

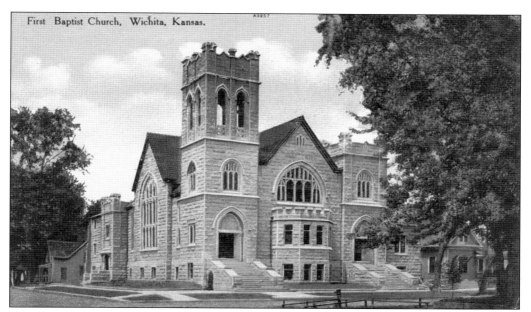

First Baptist Church, Wichita, Kansas.

The cornerstone for this church was laid on May 7, 1908, and the first service was held that fall on October 18. It was located on the northwest corner of Second Street and Broadway. The previous church was on the northeast corner of First and Market Streets. That site was sold to the Wichita Commercial Club for $10,000 on March 5, 1908, and it built a new clubhouse there.

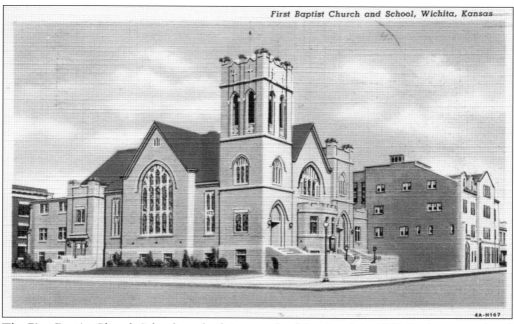

First Baptist Church and School, Wichita, Kansas

The First Baptist Church School was built just north of the church in 1928. Both were replaced in the early 1950s with the current church buildings. The new buildings traded places, with the sanctuary to the north and the education building to the south, fronting on Second Street.

The First Methodist Episcopal—now First United Methodist—Church began in May 1870 in a livery stable on North Main Street. This brick church was completed in 1885 at 320 North Broadway following two successive frame churches on the site. It served until 1923, when a new church was built just north of it. The 1885 church was finally taken down in 1949 as the new church building expanded to the south.

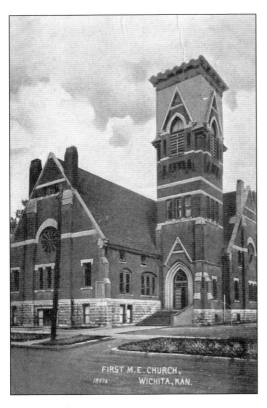

FIRST M.E. CHURCH,
18076 WICHITA, KAN.

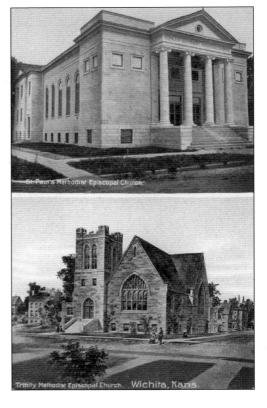

St. Paul's Methodist Episcopal Church.

Trinity Methodist Episcopal Church. Wichita, Kans.

The First Methodist Episcopal Church established a mission church on Wichita's north outskirts in 1887 called St. Paul's. A frame church was built at the southeast corner of Thirteenth Street and Broadway in 1888, then was replaced with this brick church in 1906. A westside mission grew to become Trinity Methodist Episcopal Church, which opened in 1908 on the southwest corner of Maple and Martinson Streets. Trinity merged with another church in 2004 and sold its building, but St. Paul's is still active.

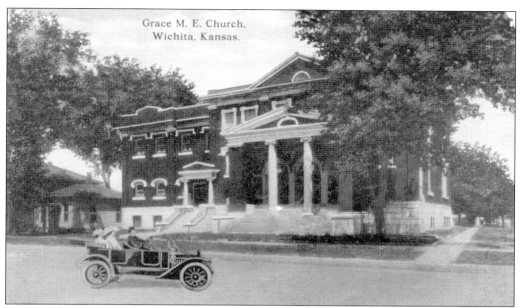

Grace M. E. Church,
Wichita, Kansas.

Grace Methodist Episcopal—now Grace United Methodist—Church was founded in 1886 on the southwest corner of Emporia Avenue and Dewey Street. This new church on the northeast corner of Topeka Avenue and Gilbert Street was dedicated on September 26, 1915, after five years of construction. A large education wing was added on the north side of the church in 1959.

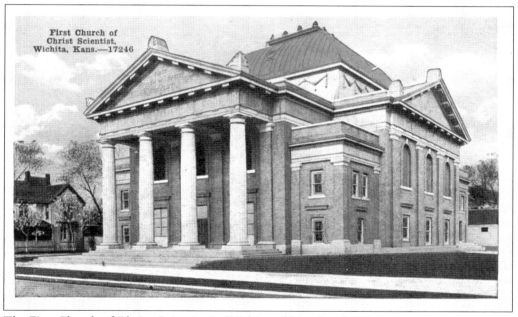

First Church of
Christ Scientist,
Wichita, Kans.—17246

The First Church of Christ, Scientist, in Wichita sold its church at 257 North Broadway—the former St. John's Episcopal Church—in 1914 and began constructing this church at 824 North Broadway. The first service was held in the new church on Thanksgiving Day, 1915. It was sold in 2005 and is now the Grand Chapel, a private venue for weddings and special events.

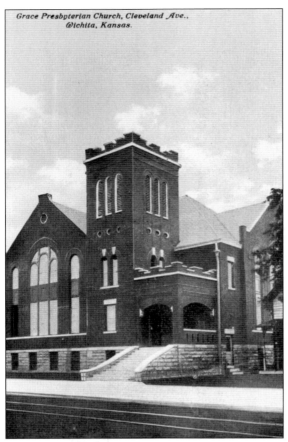

Grace Presbyterian Church, Cleveland Ave.,
Wichita, Kansas.

The Grace Presbyterian Church grew out of the First United Presbyterian Church in 1909. William Stringfield designed the new church, formerly located at 124 North Cleveland Avenue, and it was dedicated on November 20, 1910. A Sunday school building was added in 1917. The congregation held its final service here on January 26, 1941, meeting in Robinson School at 328 North Oliver Avenue until its new church at 5002 East Douglas Avenue was completed in 1947.

The Mathewson Avenue Church of Christ completed this building on the northwest corner of First Street and Mathewson Avenue in 1909. In 1941, when it bought the former Grace Presbyterian Church and moved into it, this building was razed. The congregation moved to a new octagonal-shaped church at 225 North Waco Avenue in 1971. It is now known as the RiverWalk Church of Christ. (Courtesy Wichita/Sedgwick County Historical Museum.)

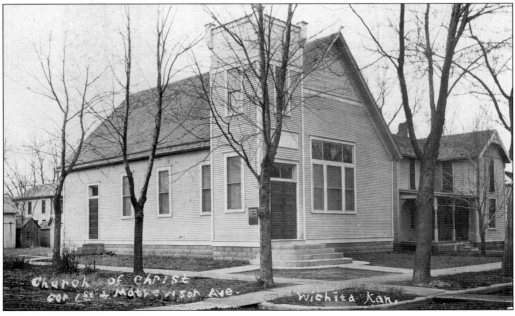

Church of Christ
cor 1st & Mathewson Ave.
Wichita Kan.

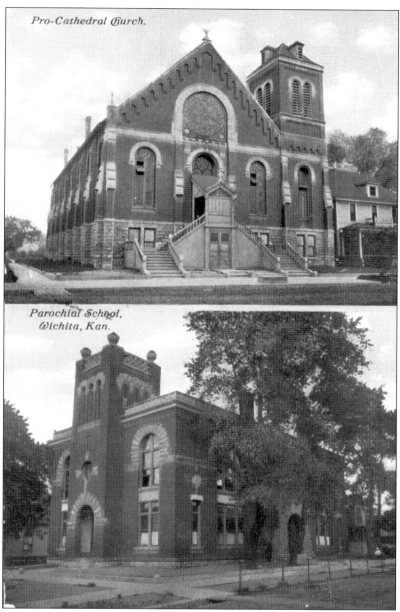

Pro-Cathedral Church.

Parochial School,
Wichita, Kan.

The Pro-Cathedral, or temporary cathedral, was built in 1887 at the southeast corner of Second Street and St. Francis Avenue and used as a house of worship until St. Mary's Cathedral was completed in 1912. It was used for concerts and as a meeting hall for the Knights of Columbus until 1920, when the Coleman Company purchased the building and used it as a factory. In 1929, it was razed and replaced with a four-story factory building. The school was constructed across the street to the north in 1888. It was demolished in 1933 to make a parking lot for the Coleman factory. The factory itself was demolished in 2011 to make a parking lot for the Intrust Arena, with a new historical feature on the corner of the intersection telling the story of the Wichita Rotary Club, which celebrated its centennial in 2011. The Coleman family was active in the Rotary Club for many decades.

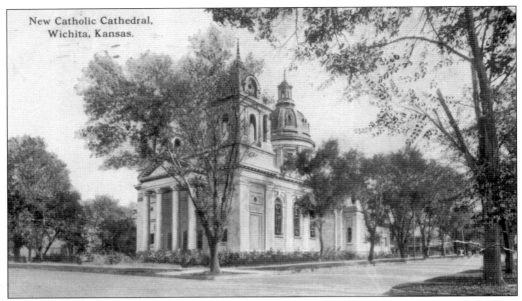

New Catholic Cathedral,
Wichita, Kansas.

In 1893, the Catholic diocese purchased James R. Mead's 1872 stone mansion and the land around it on the southeast corner of Central Avenue and Broadway. It used the residence as a rectory until 1923. St. Mary's Cathedral was built in 1910–1912 just west of the mansion. The cathedral was constructed of Bedford, Indiana, limestone, and the polished granite pillars at the north entrance were salvaged from a Chicago post office.

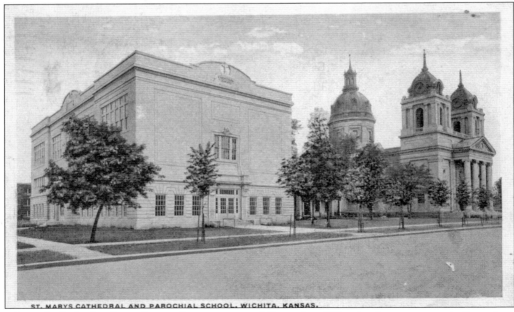

ST. MARYS CATHEDRAL AND PAROCHIAL SCHOOL, WICHITA, KANSAS.

The cathedral school, on the southwest corner of Central and Topeka Avenues, was dedicated on January 12, 1920. James R. Mead's mansion, barely visible here between the cathedral and the school, was demolished three years later and replaced with a two-story stone rectory. A major renovation of the entire campus began in 2011 that will make the former school into offices, refurbish the cathedral, and add a new entryway and gathering space to connect the buildings.

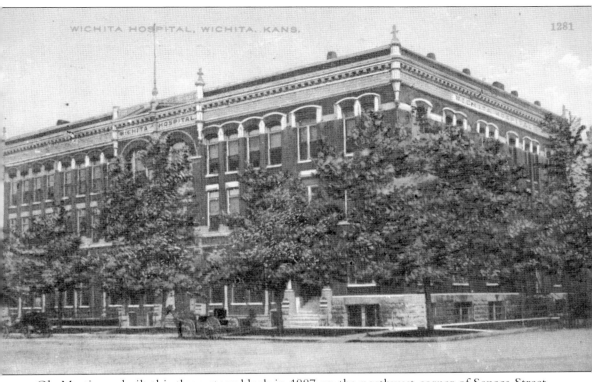

Ola Martinson built this three-story block in 1887 on the northwest corner of Seneca Street and Douglas Avenue. Proudfoot and Bird were the architects, and the West Side National Bank occupied the corner office on the first floor. Martinson's quarry near Towanda supplied the limestone for many buildings of the era. In September 1897, Martinson donated the building free and clear for use as a hospital. Wichita's first institutional medical care facility was the Women's Benevolent Home, established in 1885 at 1021 South St. Francis Avenue. The name was changed to Wichita Hospital in 1891, and it moved into the Martinson Block in 1898.

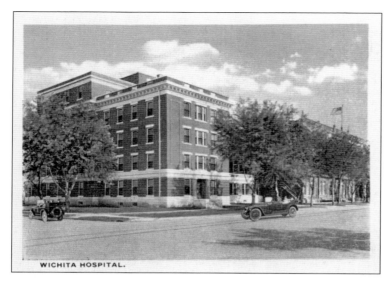

WICHITA HOSPITAL.

The annex that was added to the west side of Wichita Hospital in 1916 is seen here from the southwest. The Sisters of St. Joseph purchased the hospital in 1925 and moved part of the facilities to their new hospital on East Harry Street in 1944. The annex was then converted to a psychiatric ward. The Martinson Block was demolished in 1953, and the annex was taken down in 1972.

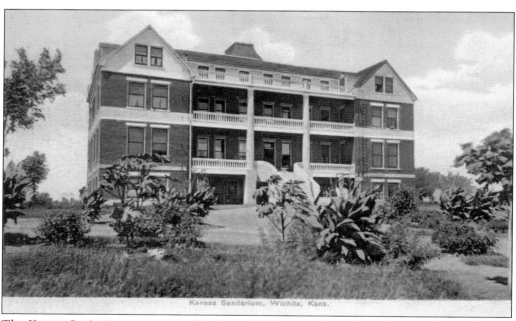

Kansas Sanitarium, Wichita, Kans.

The Kansas Sanitarium was opened in June 1905 by members of the Seventh-Day Adventist Church. It served convalescents and offered non-medicinal approaches to restoring health. This is the east side of the building, on a low hill southwest of Douglas and Sheridan Avenues in west Wichita. It was purchased by the county in 1930 and operated as a combined hospital and poor farm. All of the buildings were razed in 1953, when the land became West Douglas Park.

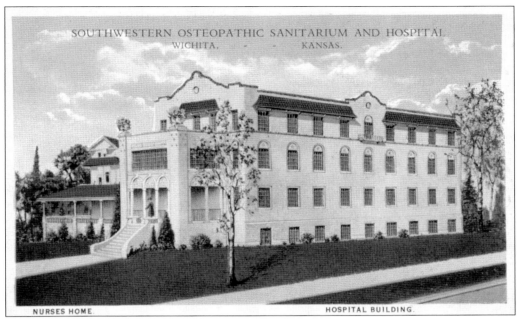

The Southwestern Osteopathic Hospital opened in Blackwell, Oklahoma, in 1912, merging with the Wichita Osteopathic Association and moving to Wichita in 1924. This four-story building was then constructed on the northwest corner of Douglas and Rutan Avenues in 1926. The John C. Rutan home, which occupied the site, was moved a short distance west and used for the nurses' residence. It is seen here to the left of the main hospital building. (Courtesy Hal Ottaway.)

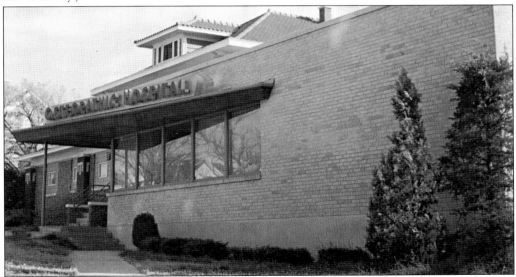

The Southwestern Osteopathic Hospital sold its buildings to the Wichita Clinic in 1947 and moved a block east to another building at the southwest corner of Douglas and Clifton Avenues, seen here from the northwest. In 1966, a much larger facility was built in west Wichita at Central Avenue and McLean Boulevard. It was later renamed Riverside Hospital and finally became part of the Via Christi hospital network.

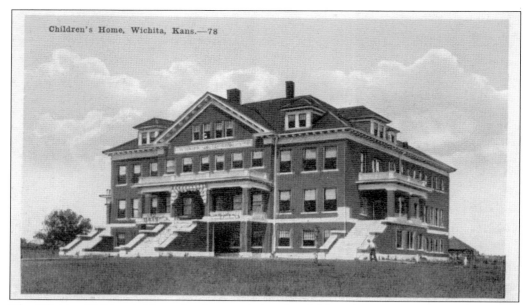

The Wichita Children's Home has been a shelter for children in crisis since 1888, but it was a marginal operation for over two decades, using converted homes before this building was constructed in 1911 at the northeast corner of Murdock and Fairmount Avenues in what was called Frisco Heights, overlooking the city from the east. Totally new facilities were constructed in 1964. This building no longer stands.

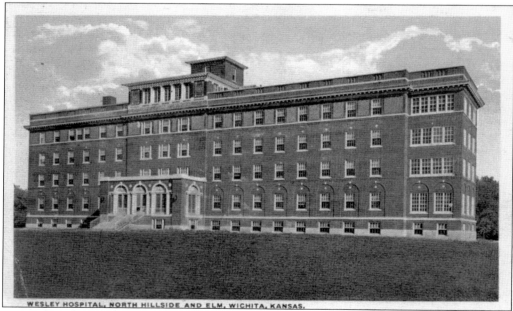

WESLEY HOSPITAL, NORTH HILLSIDE AND ELM, WICHITA, KANSAS.

The Southwest Kansas Conference of the Methodist Episcopal Church began Wesley Hospital—now Wesley Medical Center—in 1912 in a converted home at the northwest corner of Tenth Street and St. Francis Avenue. It had only 30 beds. This view looks northeast at the first building constructed on the present campus, one block north of Central Avenue on Hillside Avenue, in 1920. A fifth floor was added a few years later, with a solarium on the south end.

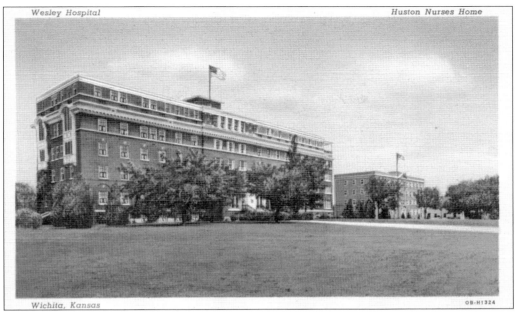

Wichita, Kansas OB-H1324

Wesley Hospital formerly had two dormitories for nurses south of the main building. The first was built in 1923 with a $30,000 donation from Alvin and Bessie Burton of Peabody, Kansas. The second was built in 1940 with a $50,000 donation from retired Wichita lumberman James H. Huston. Both were later torn down, but the facade of the Huston Nursing Home was preserved in the south side of Wesley's inner courtyard.

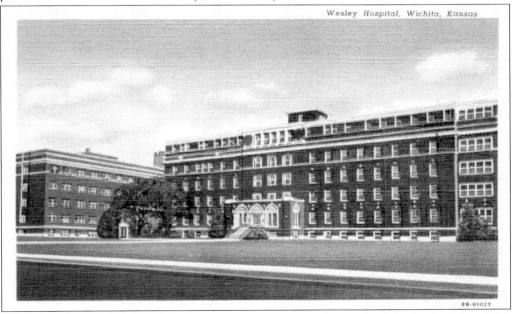

Wesley Hospital, Wichita, Kansas

9B-H1027

In 1948, Wesley Hospital opened a new maternity wing to the north of the first building. This card looks northeast at both buildings. Many later additions were made to the hospital, and the lower part of the first building is now hidden by another. However, both these structures still exist, enwrapped by the more recent buildings on the campus..

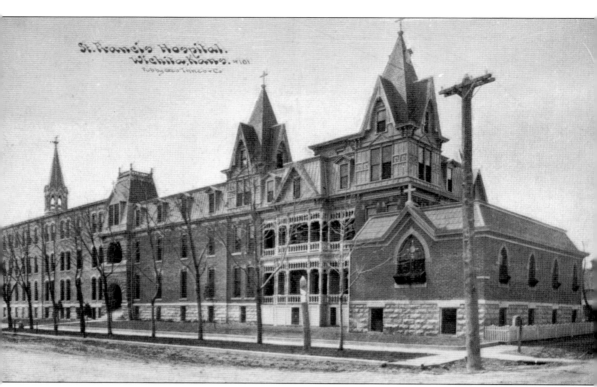

St. Francis Hospital—now called Via Christi St. Francis—began in 1888 through the efforts of a group of prominent businessmen including Burton Campbell and William Greiffenstein. A large home once owned by Henry O. Burleigh at the southwest corner of Ninth Street and North Fourth Avenue—later renamed St. Francis Avenue—was adapted for the purpose. The Sisters of the Sorrowful Mother took over operation of the hospital in 1889. This 1909 image looks from the northeast at what was the front side of the hospital. The ornate section just to the left of the chapel in the foreground was the facade of the Burleigh residence. The section with the mansard roof immediately to the left and the chapel were added in the late 1890s. The four-story section on the far left with the tall spire was built in 1908 along with a new chapel on its west side. The stone archway below the square central tower was the main entrance at the time.

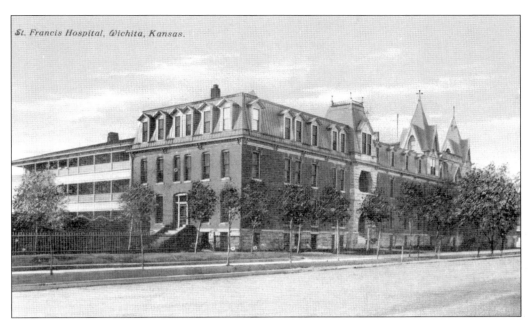

St. Francis Hospital, Wichita, Kansas.

The three-story, 45-room ward with the full-length porches on each level (left) was added to St. Francis Hospital in 1902, nearly doubling the capacity of the hospital. A large laundry was also built at this time on the north side of the new ward. This view of that ward from the southeast was blocked five years later, when the main building was extended another 100 feet south.

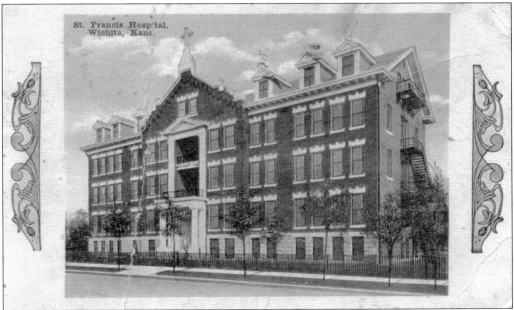

St. Francis Hospital, Wichita, Kans.

The west part of the St. Francis Hospital campus facing Emporia Avenue began with this four-story structure completed in 1915, seen here from the southwest. This became the new main entrance for the hospital, replacing the east-side entrance on St. Francis Avenue. The attic rooms housed a dormitory for the nuns. This wing was remodeled and extended at both ends in 1930 at a cost of $500,000.

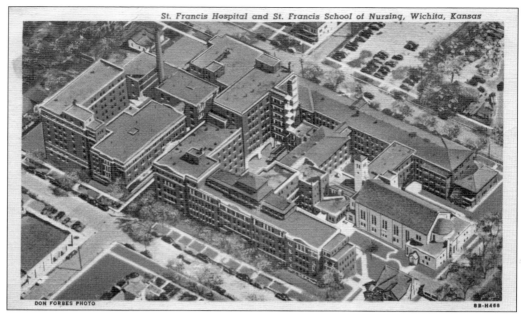

DON FORBES PHOTO

This aerial view from the southwest shows the St. Francis campus in the late 1940s. By then, a large nurses' home and school had been created north of Ninth Street, the entire east wing had been rebuilt, and the north wing was added to connect the east and west wings. The third chapel, seen on the south end, was dedicated in 1947. Today, the hospital and nearby medical specialty buildings cover 12 city blocks.

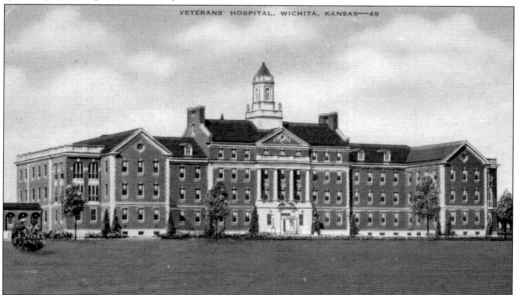

VETERANS' HOSPITAL, WICHITA, KANSAS—49

The Wichita Veterans' Hospital is northwest of East Kellogg Street and Edgemoor Drive. Its construction was approved in the early years of the Great Depression, and it was formally opened on November 16, 1933. The hospital has been expanded several times since and provides a wide range of services to area veterans. It was renamed the Robert J. Dole VA Medical Center in 2002 in honor of the long-serving US senator from Kansas, himself a World War II veteran.

Five

SCHOOLS

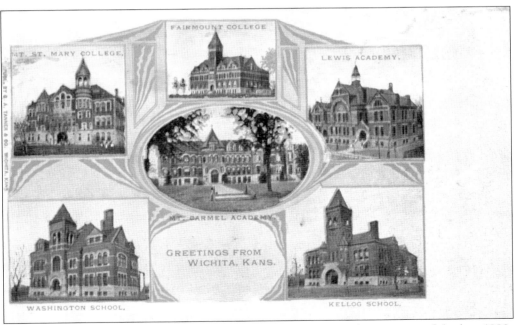

The early flowering of educational institutions during Wichita's boom years of the late 1880s produced nearly all of the buildings seen on this multi-view card. The south wing of Mount Carmel Academy, shown in the center, was built in 1901. This card has no postmark, but since Lewis Academy graduated its last class in 1909, the card must have been produced between 1901 and 1909.

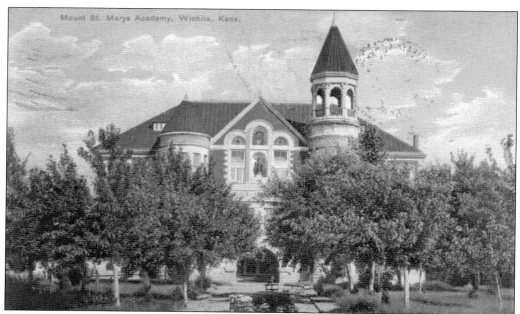

Wichita University was begun by members of the Reformed Church. This was the only building constructed for it, in 1888, a half-mile southeast of Kellogg Street and Hillside Avenue. The university only lasted six years. The building and 40 acres of land were sold to the Sisters of St. Joseph in 1899, and it became Mount St. Mary's Convent. The building burned down on September 7, 1913, and was replaced in 1915.

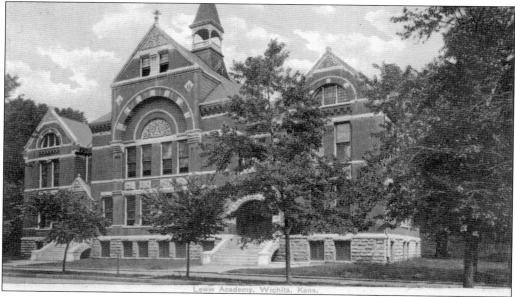

Members of the First Presbyterian Church resolved in 1885 to build a Wichita Academy at 340 North Market Street. Hiram W. Lewis, a local banker, donated $25,000 towards the school, and it was renamed for him. It was designed by Proudfoot and Bird and opened in the fall of 1886. The school closed 22 years later, and the final graduation exercises were held on June 3, 1909. The building became a YWCA in 1913 and was demolished in 1949.

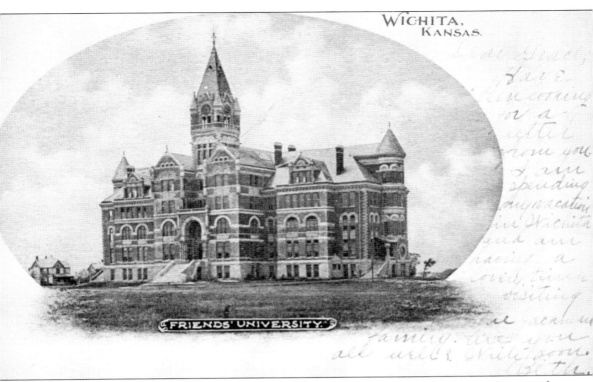

FRIENDS' UNIVERSITY.

Garfield University, initially a project of the Christian Church, rose on the flat prairie west of Wichita in 1887. There were 100 students enrolled that fall, even though the building was far from complete. Tuition was $10. However, the university foundered in 1890 after the collapse of the boom. Edgar Harding of Boston tried to restart it in 1892 and also failed. Finally, in 1898, it became Friends University after James M. Davis purchased it for $50,000 and gave it to his church. He was a devout Quaker who had made a fortune selling stereo-views of the 1893 World's Fair in Chicago. This building is now known as Davis Hall.

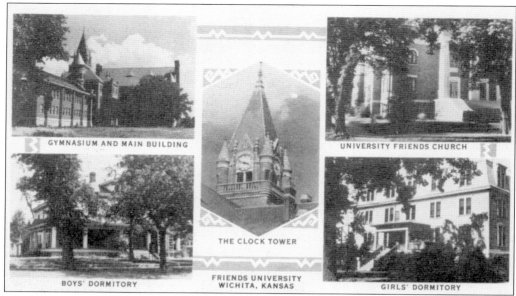

This 1930s card features vignettes of the main building of Friends University, designed by Proudfoot and Bird, and three other structures. The women's dormitory no longer exists. The church was built in 1926 one block east of the campus on the northeast corner of Glenn and University Avenues. The church and the former men's dormitory on the northeast corner of Hiram and University Avenues still exist.

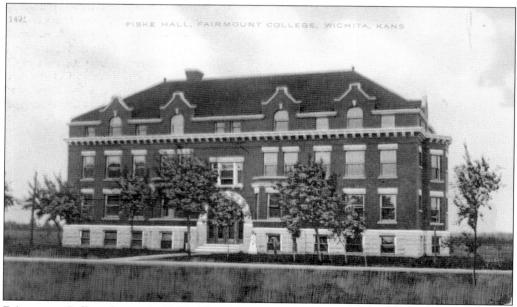

Fairmount College began in 1888. The oldest campus building remaining is Fiske Hall, seen here from the west. It was completed in 1906 and initially served as a men's dormitory with 70 occupants. It was named for Charlotte M. Fiske of Boston, whose financial support made it possible. In 1926, it was remodeled for offices and classrooms. It currently houses the history, geography, philosophy, and international programs departments.

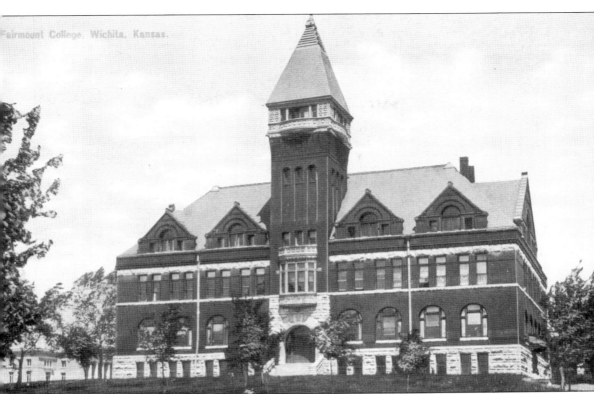

Fairmount College. Wichita. Kansas.

This card looks northwest at the original building of Fairmount College, which would eventually become Wichita State University. It was designed in 1887 by the Chicago architectural firm of Patton & Fisher. Construction began in 1888 but only got as far as enclosing the structure when the college foundered after the local economy collapsed at the end of the 1880s. In 1892, financial support from the Congregational Church helped reopen the school, and the first class of freshmen began classes on September 11, 1895. The building served for classes and offices both. It burned down on September 3, 1929, shortly after its transition to the Municipal University of Wichita.

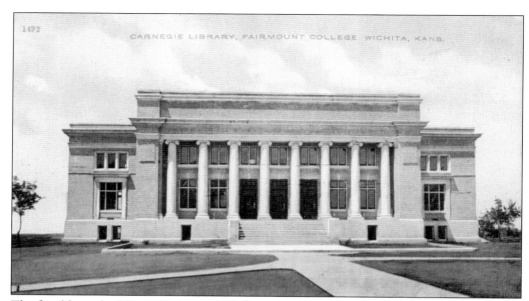

The first library building of Fairmount College was constructed in 1908 with a $40,000 grant from the Carnegie Foundation. Located where the Ulrich Art Museum is today, it was named the Morrison Library in 1911 to honor Nathan J. Morrison, the beloved first president of Fairmount College, who did not live to see this cherished goal realized. His son, Theodore, was the college librarian from 1903 to 1912. This building housed the journalism and fine arts departments from 1940 to 1964.

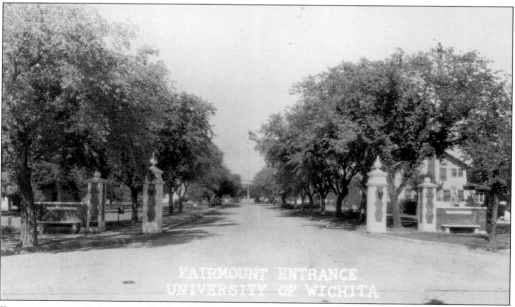

For many years, Fairmount College had only one entryway, at Seventeenth Street and Fairmount Avenue. These decorative pillars were added there as a gift from the 1929 graduating class. The Morrison Library burned in 1964, but the columned facade was retained for ornamental reasons. It was finally dismantled in 1972, but three columns were preserved and now stand immediately east of the Fairmount entrance.

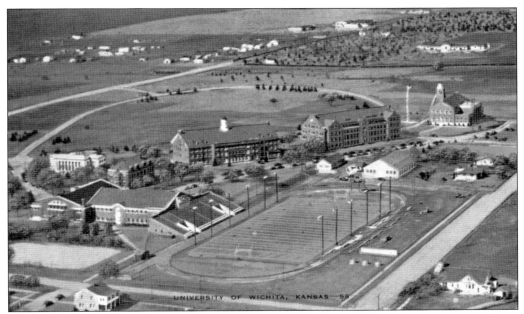

Fairmount College became the Municipal University of Wichita in 1926, and a flurry of new construction occurred over the next 15 years. This aerial view looks northwest and shows the old Morrison Library and Fiske Hall just above the gymnasium and athletic field. Next are the Science Hall, the Administration Building, and the new Morrison Library. The new library was completed in late 1939, meaning this card was created after that.

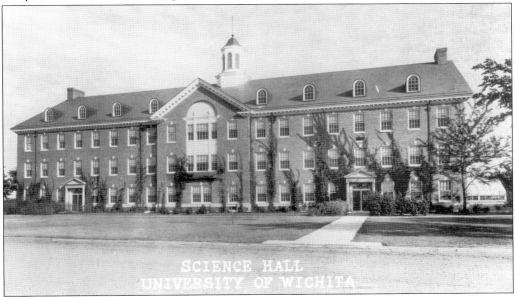

The Science Hall was constructed in 1928 and has housed various science departments since, although it is solely the home of the chemistry department today. It continued the redbrick look of Fiske Hall, with a distinctive central white tower on the roof. It was renamed Lloyd McKinley Science Hall in 1964, honoring the man who was chair of the chemistry department from 1927 to 1960.

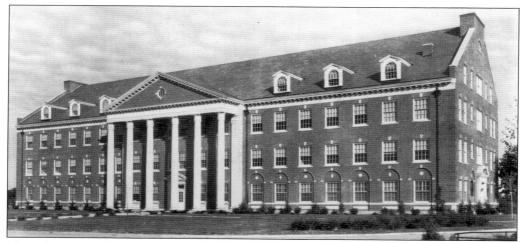

The Administration Building was the second structure completed after the school's changeover from a private college to a municipal university. It was renamed Jardine Hall in honor of William M. Jardine, who served as university president from 1934 to 1949 and had been US secretary of agriculture under Pres. Calvin Coolidge. This real-photo postcard shows the west side of the building. The University of Wichita became Wichita State University in 1964.

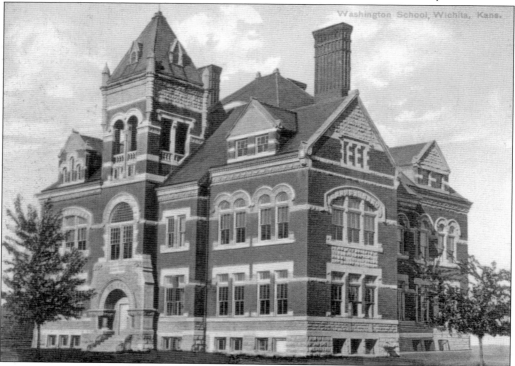

Washington School was an eight-room brick schoolhouse at the southeast corner of Third Street and Cleveland Avenue. It was one of seven school buildings constructed in 1890 after a $100,000 bond issue was narrowly approved. This view faces east. A new 21-room school was built three blocks east in 1920. The 1890 school was razed the following year, but the bricks were salvaged for a school district maintenance shop, which stood for 50 more years.

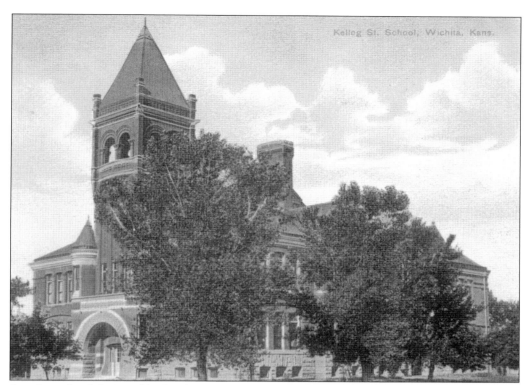

Another school designed by local architects Proudfoot and Bird was the Kellogg Street School, built in 1887 at the northeast corner of Kellogg Street and Laura Avenue. This view looks north. It was named for Milo Kellogg, Wichita's first postmaster. By 1890, Wichita had 18 public schools. A new building replaced this in 1941; it is still standing although not currently used as a public school.

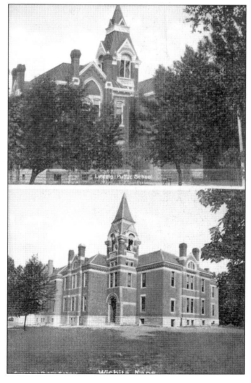

Lincoln and Franklin Schools were built in 1885 and 1886, respectively. They were designed by noted local architects Willis Proudfoot and George Bird. They were later enlarged and served more than five decades before being replaced with new buildings in 1938 (Lincoln) and 1941 (Franklin). Proudfoot and Bird designed eight public schools, but only McCormick Elementary, now used as a school museum, remains.

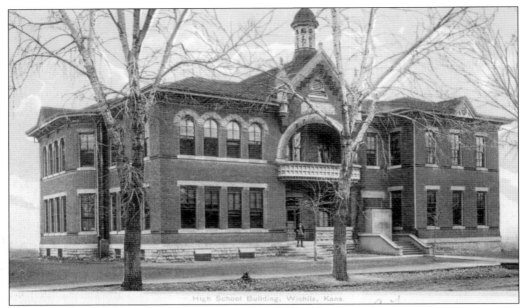

High School Building, Wichita, Kans.

Wichita built its first high school in 1884 just south of Webster School, the first public school building in the city. Both were on the east side of Emporia Avenue between Second and Third Streets, land which had been donated for public schools in 1871 by James R. Mead, one of Wichita's founders. This card shows the west side of the building. It was used for high school classes until 1923, when it was demolished.

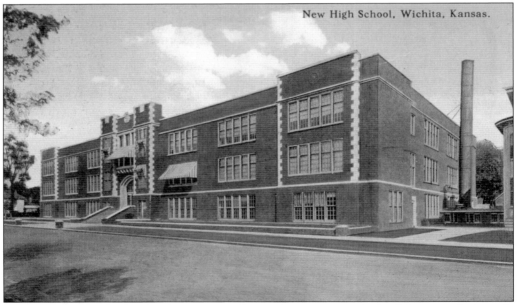

New High School, Wichita, Kansas.

Wichita built this high school in 1911 at the southeast corner of Third Street and Emporia Avenue, on the site where Webster School had stood. Wichita was growing rapidly then, and the high school was overcrowded the year after it was built. It became an intermediate school in 1923 and served in that capacity until 1961, when it became a vocational school. It was sold in 2008 and transformed into loft apartments.

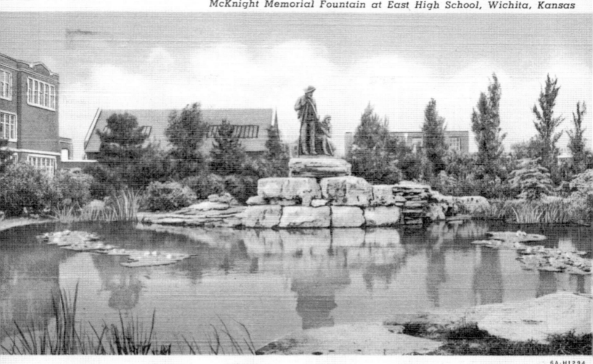

Joseph Hudson McKnight came to Wichita in the early 1880s and became wealthy in the boom later that decade. In 1896, he bought a 140-acre farm bounded by Grove Street, Douglas Avenue, Hydraulic Avenue, and Kellogg Street. He built a stylish stone residence at 206 South Hydraulic Avenue named Willowdale and lived there until his death in 1925. After his wife, Eva, died in 1927, a bequest from her estate paid for this monumental sculpture by Alexander Phimister Proctor, which was installed in 1931 on the north side of East High School. The sculpture depicts a frontiersman, his horse, and a Native American stopping to drink at a pool. The majority of Eva's estate later went to Wichita State University, helping to fund the construction of the McKnight Art Center in 1974.

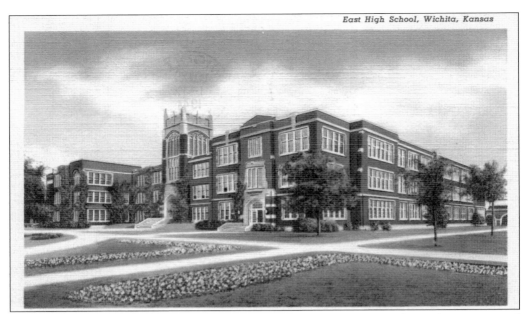

A much larger high school was built in 1923 on the southwest corner of Douglas Avenue and Grove Street and called Wichita High School until North High School was built in 1929, when it was renamed Wichita High School East. All the schools built in the 1920s were designed by local architect Lorentz Schmidt. This view shows the classic design features of the front side, which faces north. The school is still in use.

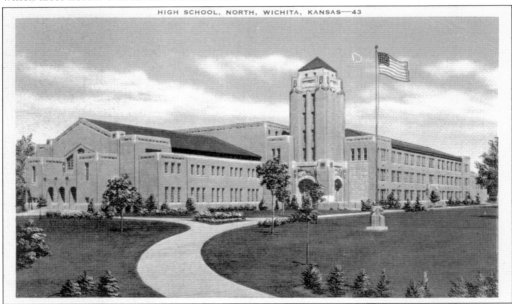

HIGH SCHOOL, NORTH, WICHITA, KANSAS—43

Wichita High School North was built in 1929 on the north side of West Thirteenth Street, just east of the Little Arkansas River. It and East High were Wichita's only two high schools until 1953, when Wichita High School West was built. The nearby river made canoeing a part of the curriculum. Students' prowess is tested in the canoe races that are part of the school's annual spring water festival.

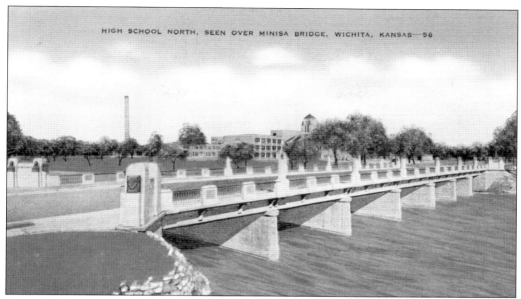

A new bridge was built in 1932 where Thirteenth Street crosses the river by North High School. Students at the school were polled to name the bridge, and they chose Minisa, a Chippewa word meaning "Red Water at Sunset." Both the bridge and the school have decorative features made of Carthalite, a cast-concrete material using pulverized colored glass for pigment. These features were designed by local sculptor Bruce Moore.

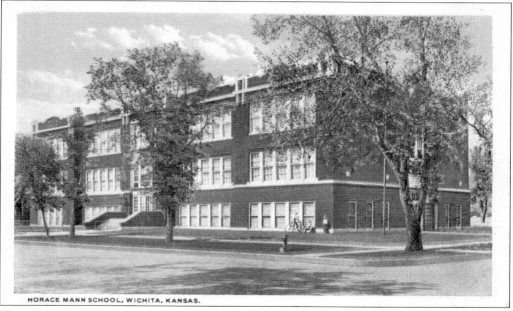

HORACE MANN SCHOOL, WICHITA, KANSAS.

Horace Mann School, Wichita's first intermediate school, was built at Twelfth and Market Streets in 1918. Built in response to the booming population of the 1910s, it had 30 pupils per classroom when it opened. Hamilton and Allison Intermediate Schools were built soon after to try to meet the need. This building was replaced in 2003, and Horace Mann is currently a dual-language magnet school for kindergarten through eighth grade.

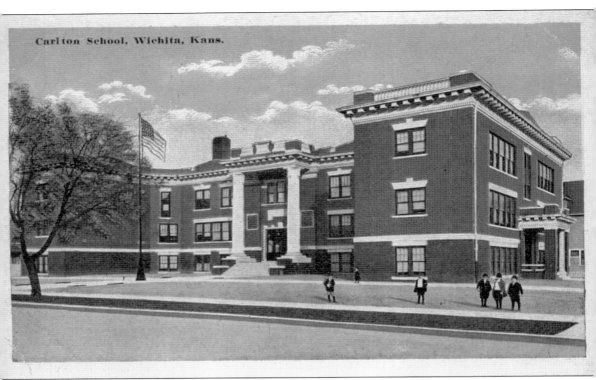

Carlton School, Wichita, Kans.

The Carleton Elementary School shown here was at the northeast corner of Broadway and Lewis Street. It was built in 1913 to replace the second school building constructed in Wichita, built in 1879. It had originally been known as the First Ward School, but the name was changed in 1885 to honor nationally known poet William McKendree Carleton, who actually visited the school in 1892. After his visit, he left a 60-pound box of candy for the children. The gesture was understandably well received. Carleton was used for administrative offices from 1946 to 1988, and the school board traded the building with the city for another property in 1993. It was demolished in 2007.

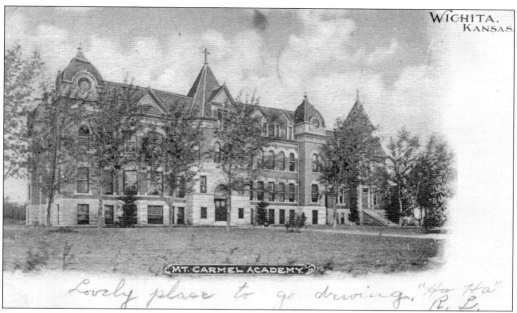

MT. CARMEL ACADEMY.

Lovely place to go driving. "Ha Ha" R. L.

Wichita's first freestanding Catholic school was All Hallows Academy, which opened in 1887 in west Wichita as a boarding school for girls. The original building is barely visible on the right in this image, most of which is filled by the south wing, added in 1901. The school was renamed Mount Carmel Academy that same year. Picture postcards of this design are the earliest type known for Wichita.

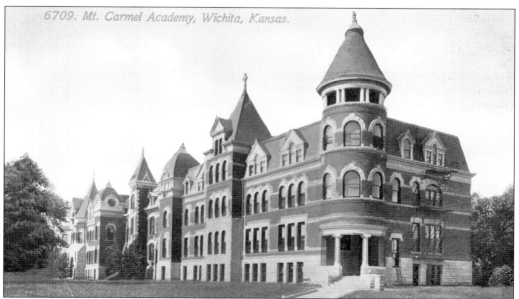

6709. Mt. Carmel Academy, Wichita, Kansas.

A second wing was added to the north side of Mount Carmel Academy in 1906, doubling its size. Mount Carmel remained at this location until 1961, when a new school was built at 8506 East Central Avenue on land formerly owned by the founder of Vickers Petroleum Company. It became coeducational when it merged with a Catholic boys' school in 1971 to become Kapaun/Mount Carmel High School.

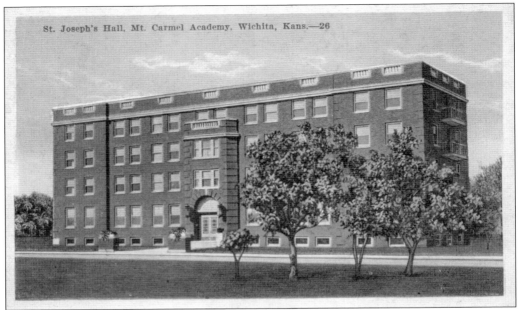

St. Joseph's Hall was a dormitory built in 1921 on the Mount Carmel Academy grounds a short distance northeast of the school building, close to Second Street. After the school moved to the east side of town, the old campus was used for religious retreat stays. All buildings on the old Mount Carmel campus were razed when the property was made into a residential development.

In 1902, the Sisters-Adorers of the Blood of Christ purchased a large home and six acres of land 2.5 miles west of downtown Wichita. It had been the home of John J. Hennessy, the local bishop. They turned it into St. John's Institute, an all-girls school. This view looks west at the front of the building. A school for young boys was added the next year, and by 1909, there were 105 students. (Courtesy Wichita/Sedgwick County Historical Museum.)

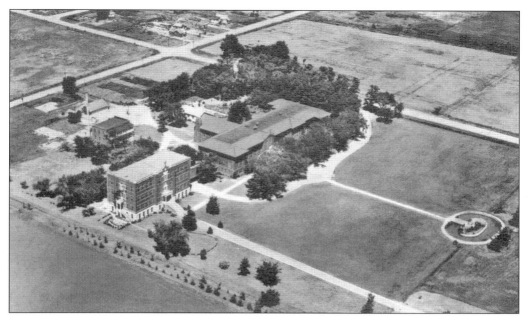

In 1922, St. John's built the large four-story building seen in the middle of this aerial view looking northwest. It partnered for five years with the Municipal University of Wichita to train teachers and later became Sacred Heart Junior College in 1933. It expanded the curriculum to become a four-year institution in the 1950s. By 1973, it was coeducational and was renamed Kansas Newman College. In 1998, it was renamed again to Newman University.

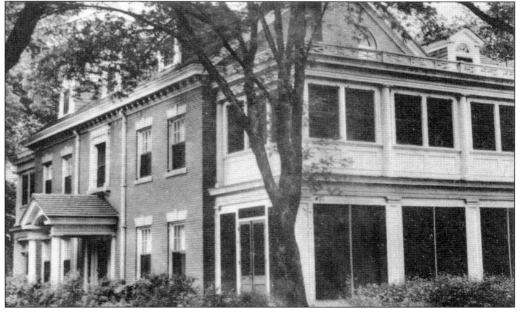

In 1918, L.W. Clapp designed this large home with a third-floor ballroom for his daughter, Sydney, and her husband, Winn Holmes, at 204 West Eighteenth Street. In 1946, eight years after the death of Sydney, Winn sold the home to Sacred Heart College, which used it as a women's residence hall until 1959. It is now owned by a substance abuse rehabilitation program.

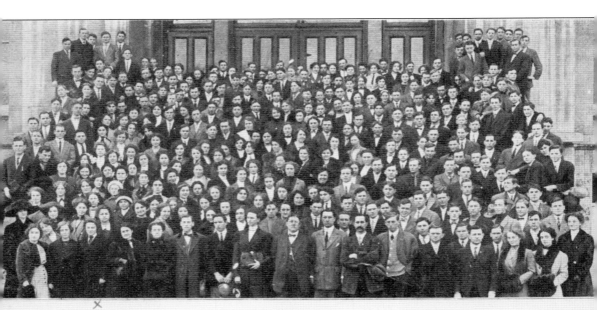

WICHITA BUSINESS COLLEGE

The largest business college in Colorado, Kansas and Oklahoma. This group of our students represents less than half of our yearly attendance.

Will G. Price, Pres
WICHITA, KANSAS

Opportunities for vocational education were also present in Wichita. The Wichita Business College, in the Zeininger Building at 114 North Market Street, trained hundreds of young men and women each year in secretarial, clerical, and managerial skills. Will G. Price became the owner of the school in 1909. This card from 1912 says it shows "less than half our yearly attendance." The photograph was taken on the steps of the county courthouse.

Six

INDUSTRIES

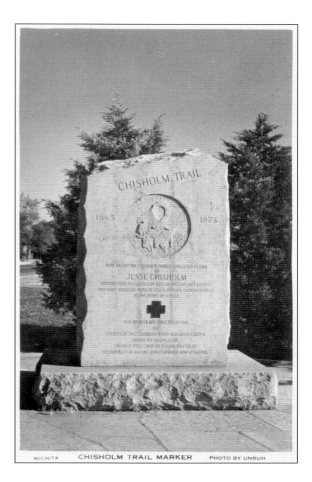

Wichita's first burst of prosperity was during the brief era of open-range cattle drives. Drovers brought up the free-roaming cattle from Texas to the railhead at Wichita on the Chisholm Trail, which crossed the Arkansas River where the Douglas Avenue Bridge is now. This granite marker was placed on the west bank of the river by the bridge in 1941 to mark that spot. Over three million head of cattle were shipped from Wichita between 1870 and 1874. Aside from the transactions of the shipping business itself, Wichita's merchants sold goods to the drovers and Wichita's saloons and hotels benefited from the free-spending cowboys.

WICHITA CHISHOLM TRAIL MARKER PHOTO BY UNRUH

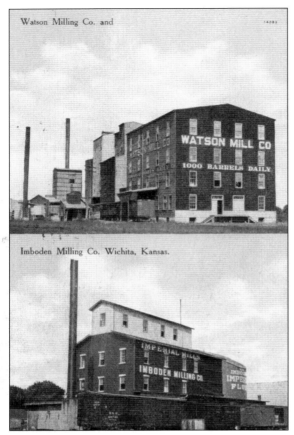

Watson Milling Co. and

Imboden Milling Co. Wichita, Kansas.

Flour milling was vital to Wichita's transition from a cow town to an agricultural center. Its first flour mill was built in 1874 at the southwest corner of Douglas and Santa Fe Avenues. Hiram Imboden was one of the men who ran it. The mill became insolvent in the depression of the 1890s, and Imboden built a new mill two blocks south in 1897, seen here from the southeast. In 1925, it was renamed Commerce Mills. That site is now encompassed by the Intrust Bank Arena.

William R. Watson came to Wichita in 1901 and built a mill along the Santa Fe Railroad tracks north of Seventeenth Street, seen here from the southwest. It was the largest mill of its day in the area, producing 230,000 barrels of flour in 1906, more than Wichita's other three mills combined. It was bought by Red Star Mills in 1913 and became its "B" unit.

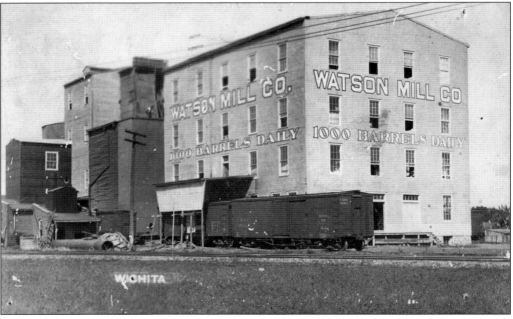

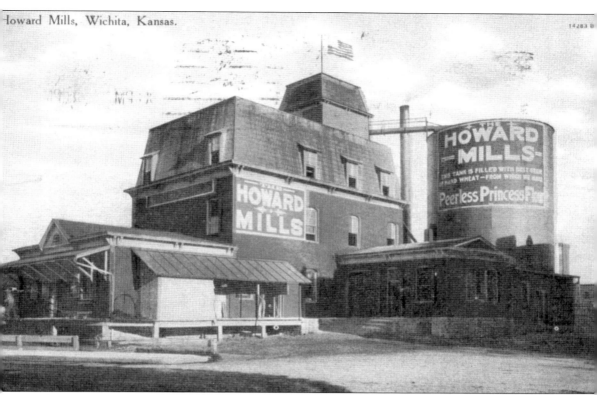

This flour mill, seen from the northwest, was built in 1899 on the southwest corner of Douglas and Waco Avenues, where A. Price Woodard Park is now. Originally called Union Mills, it was renamed Howard Mills in 1904 after Jeremiah E. Howard, who founded the firm. A Missouri Pacific Railroad spur was extended south down the middle of Waco Avenue to serve the mill and was later built farther south for the businesses and warehouses that arose in the Tractor Row area southwest of downtown. The Peerless Princess brand of flour made at the mill took its name from a Wichita slogan coined in 1886 by Marshall Murdock, the editor of the *Wichita Eagle*, who named Wichita "The Peerless Princess of the Plains." Howard sold the mill in 1914, and it burned on February 4, 1917. Oscar James Watson built a five-story warehouse on the site in 1920 that was demolished in 1969 as Wichita's urban renewal agency cleared the way for construction of the park.

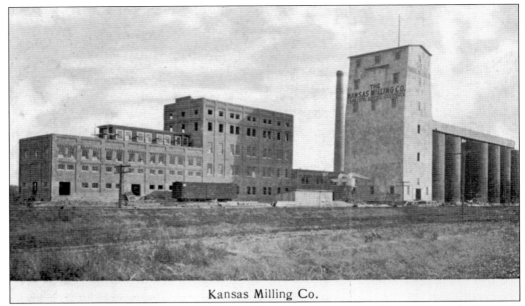

Kansas Milling Co.

Henry Lassen began the Kansas Milling Company in 1907 just south of Thirteenth Street on the east side of the Santa Fe tracks. At the start, it was the largest flour mill in the state, capable of producing 1,500 barrels of flour per day. It is currently owned by Cargill and operated as Horizon Milling. It is the only flour mill remaining in Wichita.

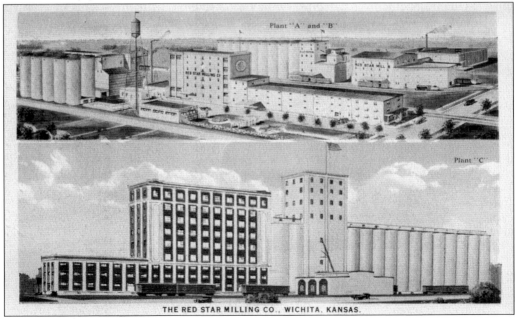

THE RED STAR MILLING CO., WICHITA, KANSAS.

The Red Star Mill began operation in 1905 east of Emporia Avenue between Eighteenth and Nineteenth Streets. In 1906, Wichita's four flour mills produced 433,000 barrels of flour valued at $1,212,400. Red Star became part of General Mills when that company formed in 1928. The Wichita milling operation was shuttered in the mid-1960s, although the elevators are still used for grain storage.

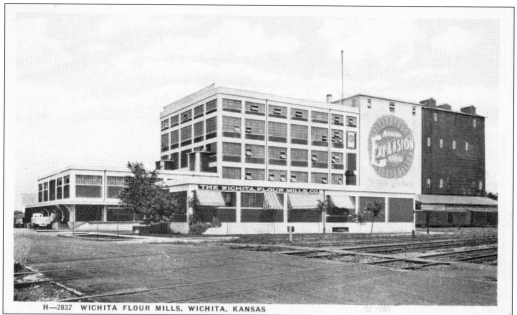

H—2837 WICHITA FLOUR MILLS, WICHITA, KANSAS

The Wichita Flour Mill began operations in 1914 on the south side of Seventeenth Street between the Rock Island and Santa Fe tracks. Initially producing 1,000 barrels of flour per day, it was more than doubled, to 2,500 barrels, only four years later. Its Kansas Expansion Flour was a well-known brand for many years. Wichita currently has a combined elevator storage capacity of 90 million bushels.

Ironworking in Wichita dates to its very first years, as blacksmiths arrived to repair and make parts for wagons. In 1887, Globe Iron Works was established northeast of Second Street and Santa Fe Avenue, where Old Town Square is now. Around 1909, its name was changed to Western Iron & Foundry. In 1912, it fabricated hundreds of decorative iron poles for new "white way" electric streetlights in Wichita's downtown.

Derrick and Ware- house Stove

Extra Heavy – For Coal, Gas, or Oil

WESTERN IRON &
FOUNDRY CO.
WICHITA, KANSAS

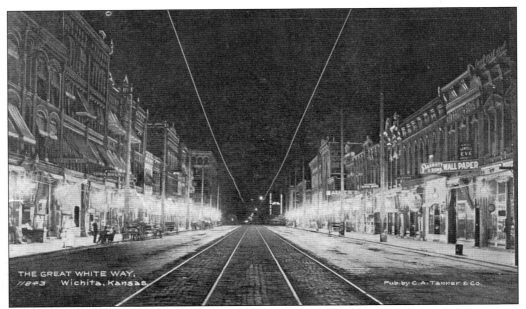

This postcard shows Wichita's "white way" street lighting system in use on the 100 block of North Main Street. The view looks south, and the postcard was mailed on December 4, 1907. In July 1907, merchants on that block installed 50 arc lamps of 2,000 candlepower each. Later, in 1907, the white way was extended one block north and then east across Douglas Avenue to the railroad tracks. (Courtesy Jeff Roth.)

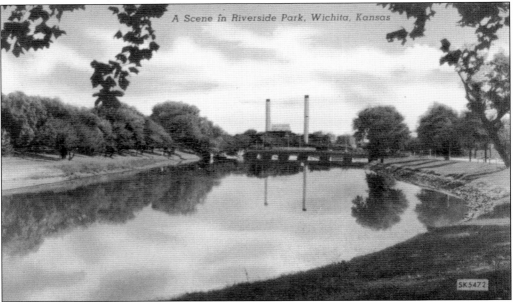

The Kansas Gas and Electric Company formed in 1910 through the merger of three utilities serving Wichita and southeast Kansas. It built a power station on the east bank of the Little Arkansas River at Third Street and expanded it nine years later to the size seen here. This view is looking east. Oil and coal were used to fuel it. The 212-foot-tall smokestacks were removed in 1968, but the building remains.

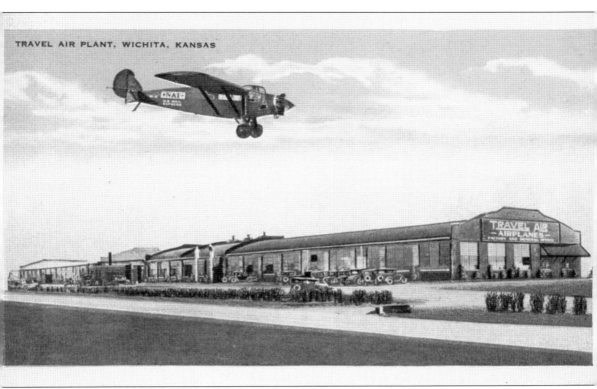

Lloyd Stearman, Clyde Cessna, and Walter Beech founded the Travel Air Company in Wichita in 1925 before going on to form their own companies, all of which still build airplanes in Wichita. That same year, Wichita won the competition to become a stop on Air Mail Route No. 3 between Chicago and Dallas. This card shows one of the eight Travel Air 5000 Series airplanes purchased in 1927 by National Air Transport (NAT) for use on that route. It is shown flying over the runway and facilities at the Travel Air plant on East Central Avenue, the airport used by NAT. The Travel Air plant was purchased in the 1930s by Beech Aircraft, which still occupies the site. NAT would later become part of United Air Lines. Travel Air went on to produce the famous Mystery S model, which won the unlimited class at the Cleveland Air Races on September 2, 1929. But the onset of the Great Depression led to the end of the company.

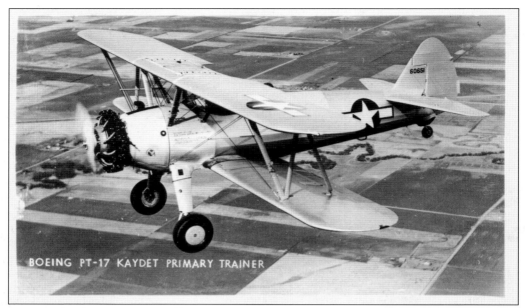

BOEING PT-17 KAYDET PRIMARY TRAINER

In 1926, Lloyd Stearman started his own aircraft company in Wichita. It was acquired in 1929 by United Aircraft and Transport Company, which also owned Boeing. The Stearman plant became the Wichita division of Boeing in 1934. It developed a single-engine trainer called the Kaydet that was widely adopted by the armed forces during World War II. The plant produced 10,346 Kaydets between 1939 and 1945, along with parts for B-17 bombers and 1,665 B-29 bombers.

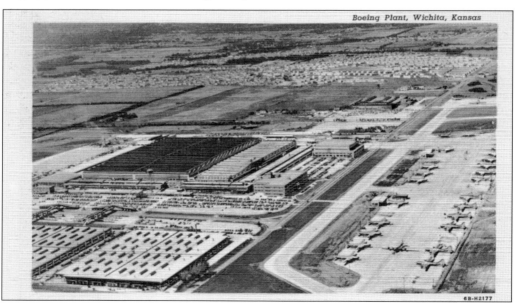

Boeing Plant, Wichita, Kansas

This aerial view looks northwest at the Wichita Boeing plant during the time it was producing the B-29, several of which are shown parked nearby. Thousands of workers were hired for wartime production, and after the war, thousands were laid off. Wichita's economy has waxed and waned with the prosperity of the aircraft industry ever since. In January 2012, Boeing announced it would close its Wichita plant at the end of 2013.

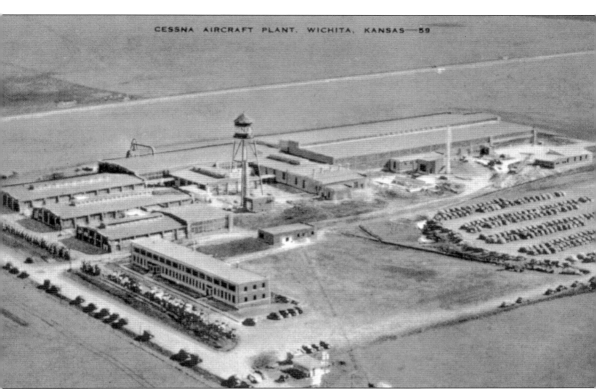

Clyde Cessna, a farm boy from Kingman County, Kansas, was a mechanical genius who bought and began tinkering with his own airplane in 1911. He dazzled Wichita with exhibition flights during the fall fair weekend of October 17–19, 1913, using the field at Walnut Grove north of town as his airport. He began manufacturing airplanes in Wichita in 1916. After helping found Travel Air Company in 1925, he formed another company and, in 1927, built a monoplane with a cantilevered high-wing design that revolutionized the industry. His company nearly went under during the Great Depression, but it recovered later in the decade and prospered during World War II with production of twin-engine trainer aircraft for both the US and Canadian militaries. This aerial view looks southeast at the Cessna plant as it appeared during World War II. South Woodlawn Boulevard is in the background.

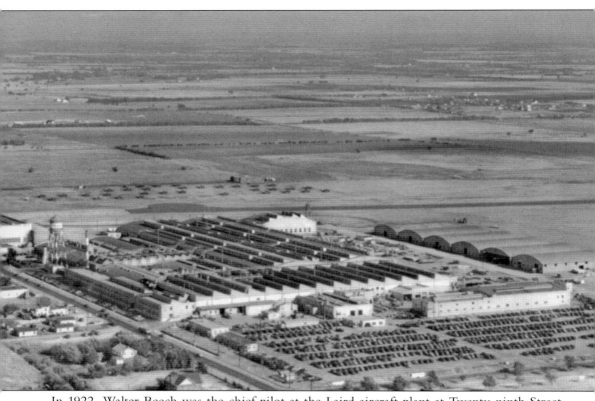

In 1922, Walter Beech was the chief pilot at the Laird aircraft plant at Twenty-ninth Street North and Hillside Avenue. He soon moved into management but was lured away to the start-up Travel Air Company in 1925. When it merged with Curtiss-Wright, he moved to St. Louis, eventually becoming president of the firm. In 1932, he quit and came back to Wichita to found his own company. Initially, he leased space in the Cessna plant, which was largely idle at the time. Less than a year later, he created a sensation when he toured the country with his radical Staggerwing biplane. In 1934, Beech moved his company into the old Travel Air plant on East Central Avenue. During World War II, Beechcraft received over $75 million in defense contracts and expanded to the size seen in this aerial view. This postcard was a company promotional item. On the back is the motto: "The World Is Small when You Fly a Beechcraft."

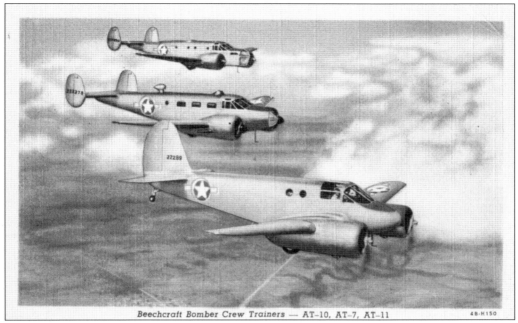

Beechcraft Bomber Crew Trainers — AT-10, AT-7, AT-11 4B-H150

A major part of the defense work Beechcraft did during World War II was building these planes, which were used to train the men who would fly in the big bombers. The lead plane is an AT-10 Pilot Trainer, followed by an AT-7 Navigation Trainer and an AT-11 Bombing and Gunnery Trainer. These postcards were given away by the company to its employees in 1944. (Courtesy Jeff Roth.)

Worth Waiting For!
That day when he'll be back! And so are Culver's new postwar Victory Model Airplanes

The Culver Aircraft Company started in Columbus, Ohio, in 1938 and moved to Wichita in 1940. Culver produced radio-controlled target drones during World War II. This postcard came out near the end of the war, and its style tapped into people's longing to have their sons and husbands back home again. Culver hoped to succeed after the war with its new Model V, but the company went bankrupt in late 1946.

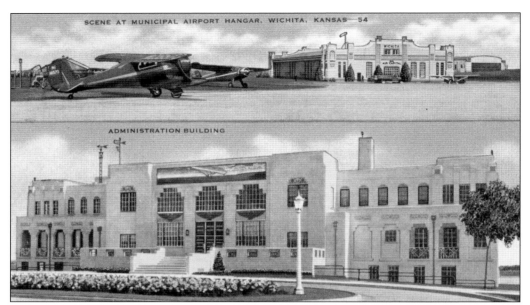

In 1928, the Wichita Park Board bought a square mile of high ground four miles southeast of downtown for development as a municipal airport. Local architect Glen Thomas drew plans for the administration building. The central part of it, shown here, was not completed until 1935. The 37-foot-long Carthalite mural over the entrance was designed by L.W. Clapp, the president of the park board. This building now houses the Kansas Aviation Museum.

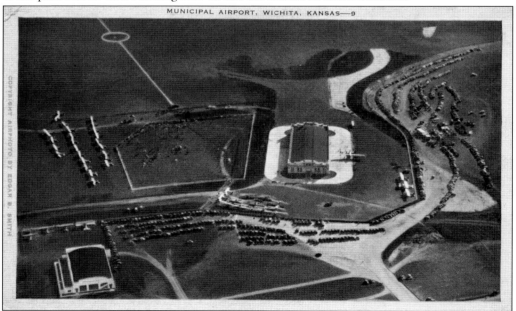

The hangar at the municipal airport was completed in 1929. This aerial view looks southwest at the airport on what was likely the day of an air show. Dozens of small planes are parked nearby along with the cars of hundreds of visitors. The photograph was taken by Edgar B. Smith, a local photographer who specialized in aerial views of Wichita. The hangar burned down on September 25, 1945.

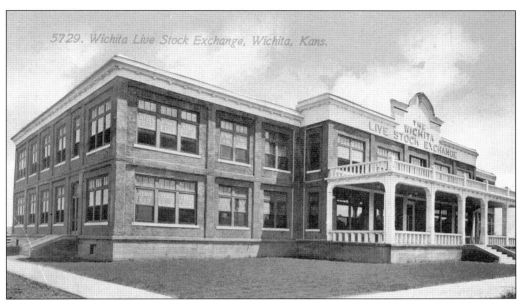

Holding pens for livestock awaiting shipment were located east of downtown in Wichita's early years. The Union Stock Yards Company formed in 1887 and initially built near Eighteenth Street and Emporia Avenue but later moved north to be nearer to the meatpacking plants. The Exchange Building was completed in 1910 on the north side of Twenty-first Street, five blocks east of Broadway. All the business associated with livestock sales occurred here.

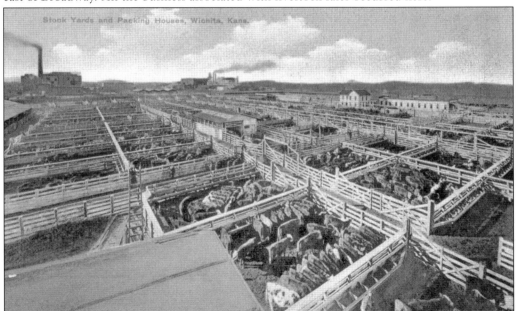

The sorting pens for livestock stretched north of the Exchange Building for many acres, and two fenced roads led west to the Dold and Cudahy packing plants seen in the distance. After 92 years of operation, Wichita's Union Stock Yards shut down in November 1979. The Exchange Building is gone, and the land formerly occupied by thousands of bawling cattle is now an automobile salvage yard.

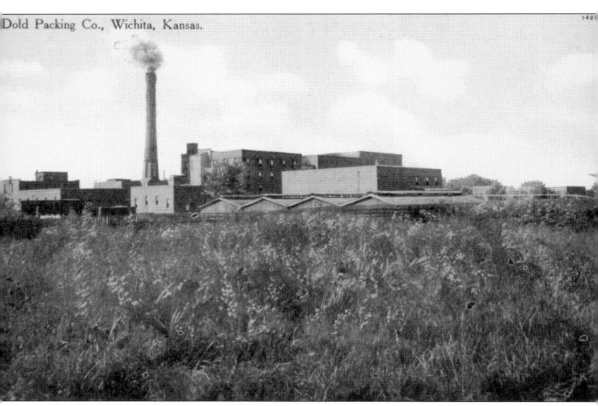

Dold Packing Co., Wichita, Kansas.

Wichita had various small packinghouses in its early years that only operated during winter due to the lack of refrigeration. One hog slaughterhouse was downtown on the south side of Douglas Avenue where Kennedy Plaza is today. The city attracted two large meatpacking firms at the end of the 1880s, both located northeast of North Twenty-first Street and Broadway. The Dold plant was closer to the intersection and the first to open, on November 28, 1888. It burned down on July 16, 1901, in a spectacular blaze visible for 20 miles. The company promptly rebuilt with a larger facility. This view looks southwest at the rebuilt plant, an angle that does not show the Cudahy plant to its north. The facility continued to operate until the early 1970s, when it closed and was torn down.

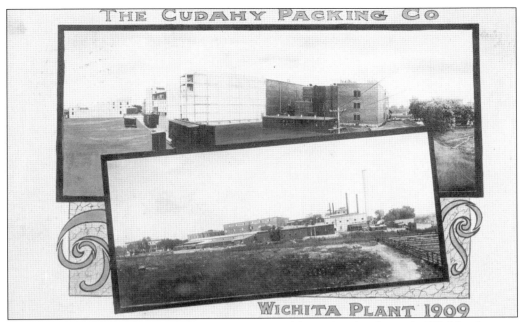

The Francis Whittaker packing plant was the second large slaughterhouse in Wichita. It was a block north of the Dold plant and began slaughtering hogs on August 1, 1889. It went bankrupt five years later but was restarted and then taken over in 1900 by the Cudahy firm. The plant was greatly expanded in 1909, and this postcard invitation to view the new facility was mailed to customers and vendors.

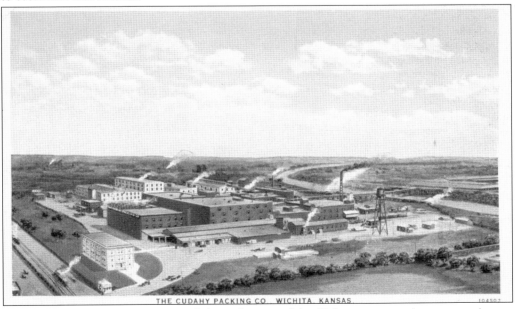

The Cudahy packing plant operated through most of the 20th century, at times processing up to 4,000 hogs per day. This aerial view looks northeast at it, not showing the Dold plant to its south. It closed in 1976, and the facility has since been used by other firms for the production of smoked meats but not as a slaughterhouse. The plant is currently vacant.

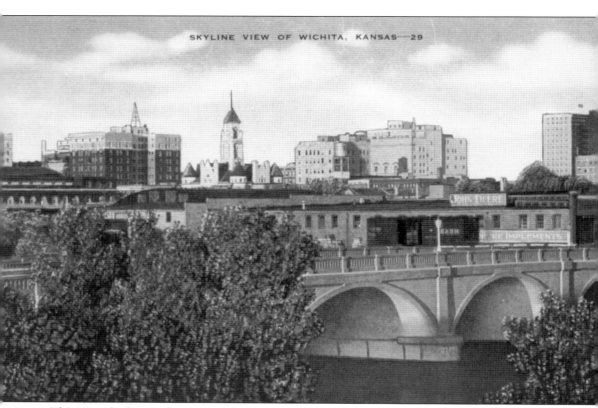

This view looks northeast towards downtown, past the Maple/Lewis Street bridge over the Arkansas River. This bridge was built in 1922 and named for James Murry, who served in city government for over two decades as chief of police and superintendent of streets, among other roles. A new bridge replaced it in the late 1990s. The area between the bridge and downtown was predominantly an industrial and warehouse district for many decades. The Forum was also located in that area. Several farm implement dealers, including the John Deere distributor seen here, were located along two blocks of South Wichita Street, the first street east of the bridge, known as Tractor Row. Those buildings were all cleared during the urban renewal era of the 1960s, and the area now contains the Central Library, the Hyatt Regency Hotel, and the Century II Performing Arts and Convention Center.

Seven

PASTIMES

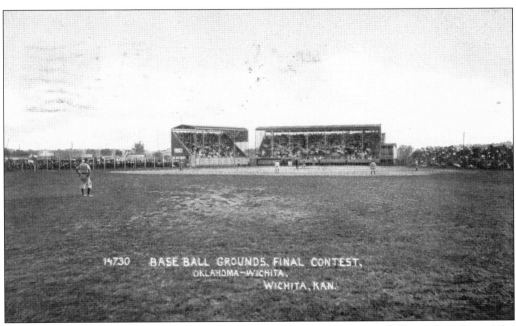

14730 BASE BALL GROUNDS, FINAL CONTEST,
OKLAHOMA—WICHITA.
WICHITA, KAN.

Baseball has been played in Wichita since the early 1870s in many different locations. The Western Association Ballpark was built in 1905 at the old fairgrounds southwest of Main Street and Mount Vernon Road. A half-mile horse-racing track was located there for several years, and the park hosted the state fair in the 1890s. The Wichita Jobbers baseball team played there until 1911.

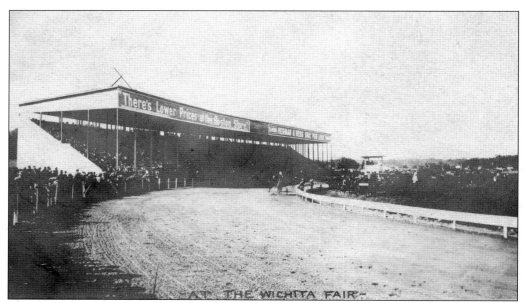

The Wichita and Southwestern Fair Association incorporated in 1906, purchasing 31 acres west of the Arkansas River and northeast of Second and Osage Streets. It built this grandstand and a large stable facility for horses and held its first fair on September 23–28, 1907. The stables burned on November 20, 1910, and the property was bought by the Midland Valley Railroad in 1911. The final event there was an automobile race on July 4, 1911.

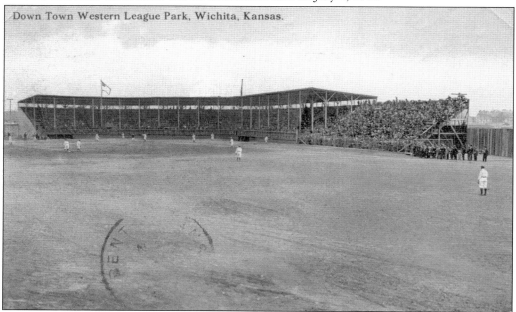

In 1912, Island Park baseball stadium was built on Ackerman Island in the Arkansas River. The grandstand faced north about midway between the Douglas Avenue and Second Street bridges. Fans could reach the stadium either by walking down a stairway from the Douglas Avenue Bridge or by taking the Wonderland Park streetcars. The stadium was torn down in 1933, just prior to the removal of Ackerman Island.

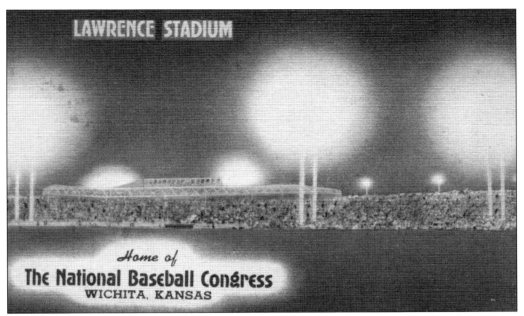

Lawrence Stadium—now Lawrence-Dumont Stadium—was built as a federal Public Works project in 1934 on an open field west of the Arkansas River, two blocks south of Douglas Avenue. In 1935, it was the site of the first National Baseball Congress World Series, the national amateur and semipro tournament that has been held there every year since. Fans attending games have a panoramic view of downtown from the stadium.

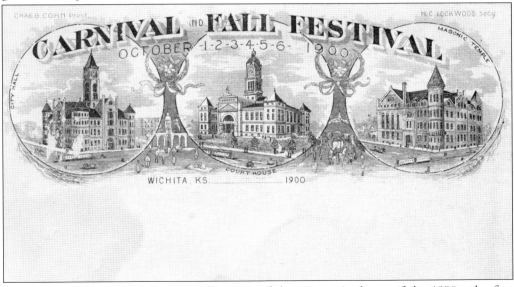

In October 1899, as Wichita was pulling out of the economic slump of the 1890s, the first downtown carnival was held. It became an annual civic celebration and went on for many years. Charles Cohn, the co-owner of the Boston Store, and Harry Lockwood were the organizers, as noted on this invitation postcard for the 1900 event. The design features cameos of three prominent downtown buildings with the illustrations between reflecting that year's Near East theme.

At the end of the 1900 street fair, the entryway arch on Main Street was moved to the Murdock Avenue entrance to Riverside Park. It was covered in a brick veneer and stood there until March 1913, when it was removed. This real-photo postcard looks at the arch from Waco Avenue. The first Murdock Avenue Bridge is beyond it, and the early version of the Riverside Boat House is to its left.

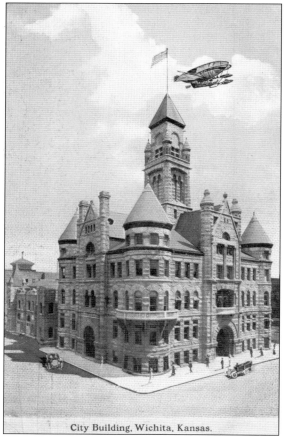

City Building, Wichita, Kansas.

In 1908, the annual fall celebration was renamed the Peerless Prophets Jubilee. Augustus Roy Knabenshue brought his airship to Wichita that year for demonstration flights during the event. The airship was a small dirigible with a motor-driven propeller. This postcard appeared that year, although the scene shown here never actually happened. Due to high winds, the airship was only able to fly one day, and its journey was merely a lap around Ackerman Island.

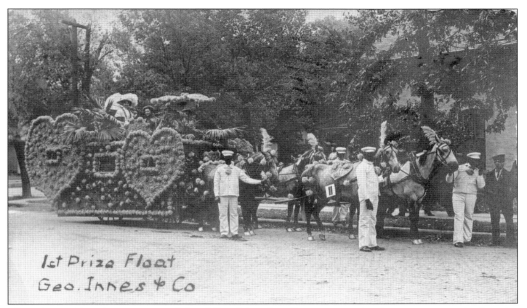

1st Prize Float
Geo. Innes & Co

The Flower Parade was part of the fall celebration for many years. It was patterned after the Tournament of Roses Parade in Pasadena, California, with the parade vehicles covered with flowers in extravagant designs. The George Innes Store decorated one of its horse-drawn delivery wagons for its 1909 entry, which was awarded first place in the float category. The festival queen and her maids of honor are riding in the carriage.

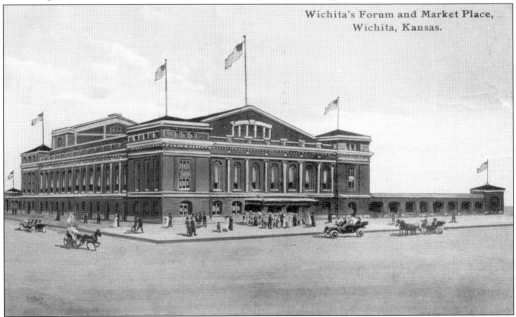

Wichita's Forum and Market Place, Wichita, Kansas.

On April 6, 1909, Wichita voters approved $150,000 in bonds to construct a new downtown auditorium and marketplace. Construction began in May 1910, and it opened in 1911. It was called the Forum and was on the northwest corner of Water and English Streets. This postcard shows the auditorium on the left and the stalls of the marketplace extending to the north.

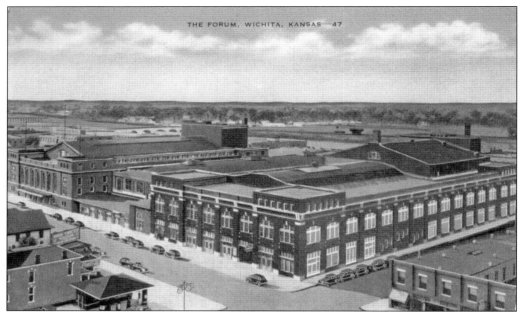

It became immediately obvious that the Forum needed to be bigger. A one-story frame annex was added to the north side of the auditorium in 1912. Then, in 1917, voters approved a $200,000 bond issue to further expand the building. This aerial view from the northeast shows the completed Forum Building, including the Exposition Building on the near corner and the Arcadia Theater adjoining it on the west.

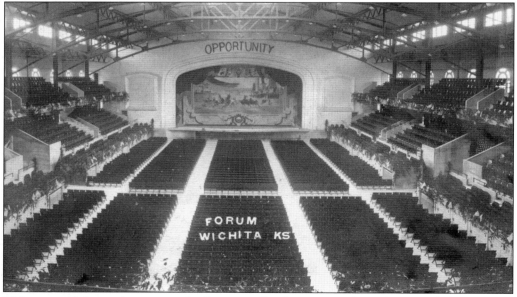

This postcard shows the stage at the Forum auditorium as seen from the upper balcony at the east end. The inaugural performance was on January 25, 1911, with the Cincinnati Symphony Orchestra and a 400-member local chorus performing the oratorio *The Children's Crusade* for a crowd of 5,000. The first high school commencement exercises were held there on May 24, with many more held in subsequent decades.

The proscenium fire curtain at the Forum featured a reproduction of E. Cameron's painting depicting the chariot race from *Ben Hur*. The asbestos curtain was 63 feet wide by 37 feet high, bigger than any other in the United States at the time except for the one at the Hippodrome in New York City. In its 54 years of existence, the Wichita Forum and Exposition Hall hosted many concerts, conventions, graduation exercises, and trade shows.

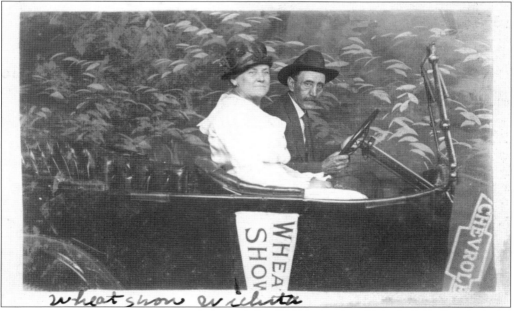

In late September or early October every year from 1911 to 1924, the Forum was the site of the International Wheat Show and Exhibition. Displays of produce and farm equipment shared the floor space with many other types of merchandise. As automobiles were becoming popular, dealerships promoted their vehicles there as well. This real-photo postcard shows a happy couple sitting in a new Chevrolet at the show.

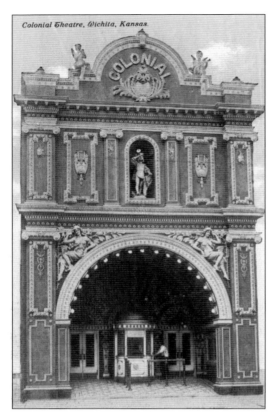

Colonial Theatre, Wichita, Kansas.

Fritz Schnitzler, who had been an early Wichita saloonkeeper, constructed this building in 1885 at 117 North Market Street, on the west side just north of the alley. It was a movie theater from 1910 to 1922, first as the Colonial then as the Regent. It had a very brightly lit marquee at night. A succession of different businesses followed before it was razed in 1962. A parking garage is on the site now.

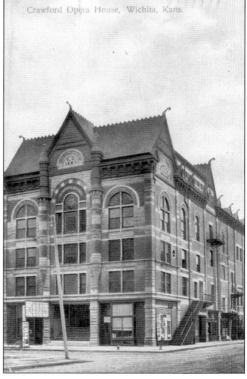

Crawford Opera House, Wichita, Kans.

The Crawford Grand Opera House was on the southwest corner of Topeka Avenue and William Street. It opened on February 1, 1888, with a production of *The Gypsy Baron* by Johann Strauss. It was an intimate theater and very elegantly appointed inside, with a curved balcony. It became the Lyceum Theater in 1911 after a new Crawford Theater was built two doors south. The Lyceum burned down in 1913, and the new Crawford was razed in 1956.

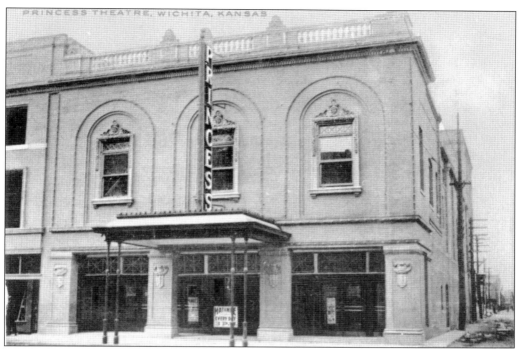

Dr. Lewis M. Miller, a former dentist, opened the Princess Theater on April 5, 1909, at 115 South Broadway. The Princess featured vaudeville acts and could seat 1,000 people. It was changed to a movie theater in 1917, and in 1927, the Princess and the two buildings south of it were replaced with the new Innes Store.

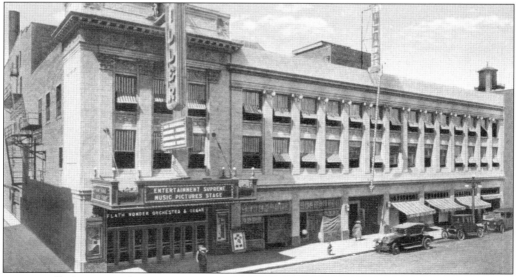

Lewis Miller's passion for the theater business led him to build the magnificent Miller Theater at 113 North Broadway in 1922, complete with a $40,000 Wurlitzer pipe organ. The last movie was shown there on March 24, 1970. In 1973, Wichita's grandest theater was replaced with a parking garage. Miller left $1 million to Wichita State University in his will, and the Miller Concert Hall in the Duerksen Fine Arts Center is named for him.

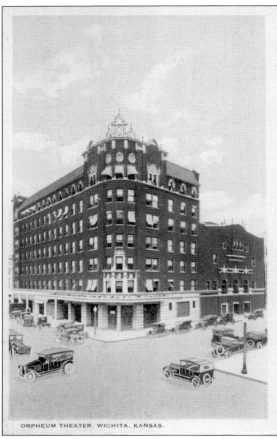

ORPHEUM THEATER. WICHITA. KANSAS.

The Orpheum Theater opened on Labor Day, 1922, at the northeast corner of Broadway and First Street. It was the first "atmospheric" theater in the nation, with an interior design evoking a Spanish villa at night. It became part of the Fox chain of theaters in 1929 and was converted to showing talking movies. It closed in 1976. A nonprofit group began working to preserve and restore it in 1985, and it now regularly hosts a variety of musical performances. (Courtesy Wichita/ Sedgwick County Historical Museum.)

Some prominent citizens in the Riverside neighborhood incorporated the Riverside Club in 1908. They built a clubhouse on the northwest corner of North River Boulevard and Briggs Street, the present site of Gloria Dei Lutheran Church. It opened on February 24, 1910. This card was probably based on a design sketch from the architect, F.E. Parker and Son of Kansas City, Missouri. The club went bankrupt in 1917, and the building was demolished in 1928.

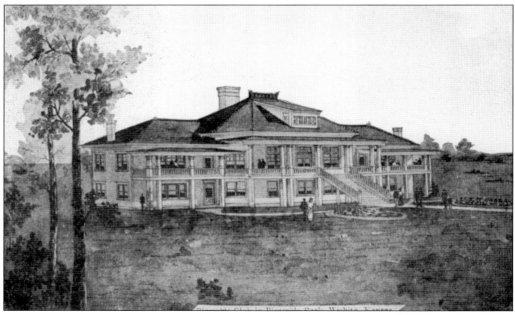

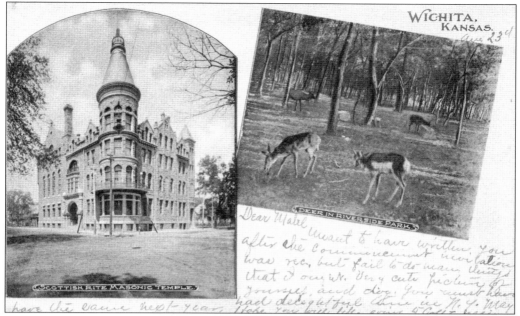

Along with the Scottish Rite Temple downtown, seen here in its original size, this card shows the first three species kept at the Riverside Park Zoo: deer, pronghorn antelope, and elk. The message written on the front was typical for undivided back postcards produced between 1901 and 1907. The zoo began in 1901, and this card could have been made as early as 1902, as those animals were all present in the zoo by then.

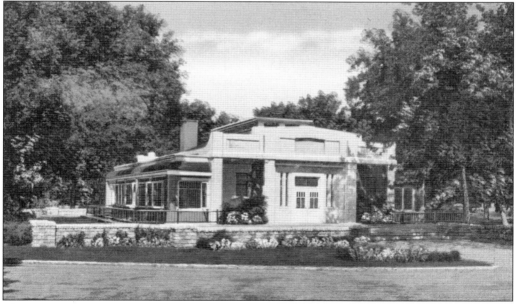

The Riverside Park Zoo added this central animal house in 1928 where the Kansas Wildlife Exhibit is today. Lions and other big cats were in the cages on the south side of the building, and various primates were on the north side. Visitors could see the animals from the inside or outside. This building was demolished in 1973 after the new Sedgwick County Zoo opened.

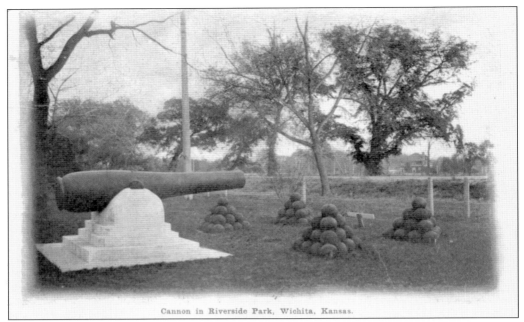

Cannon in Riverside Park, Wichita, Kansas.

Shortly after the city developed the riverside parks, this leftover Civil War materiel was secured from the federal government for placement there. It was installed in North Riverside Park in December 1898, about one block west of the streetcar line on Bitting Avenue. This view is from the west. The cannon was donated for scrap iron as part of the war effort in 1942.

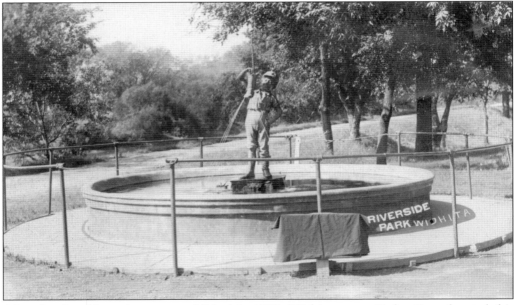

After the riverside parks were established in 1898, Wichita mayor Finlay Ross donated this interesting fountain sculpture "for the children of Wichita." It was installed in North Riverside Park in the spring of 1899, a short distance west of the cannon. In this real-photo postcard, the photographer's jacket was draped over a directional sign attached to the fence. The fountain was removed in the late 1920s after being hit by a car.

118

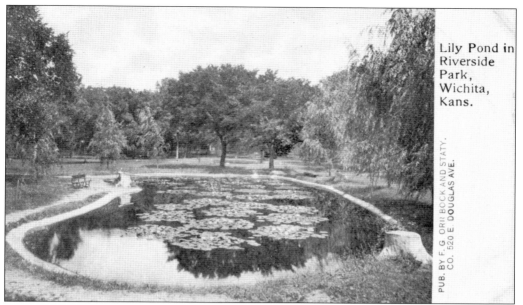

Lily Pond in Riverside Park, Wichita, Kans.

PUB. BY F. G. ORR BOOK AND STATY. CO. 520 E. DOUGLAS AVE.

A concrete lily pond was created in North Riverside Park in 1902, a short distance west of Bitting Avenue. It still exists today. This early view looking north predates the construction of Park Villa in 1912. F.G. Orr Book and Stationery Company produced this postcard and many others. Orr's bookstores were a part of Wichita from 1902 to 1972, when the name was changed to McLeod's.

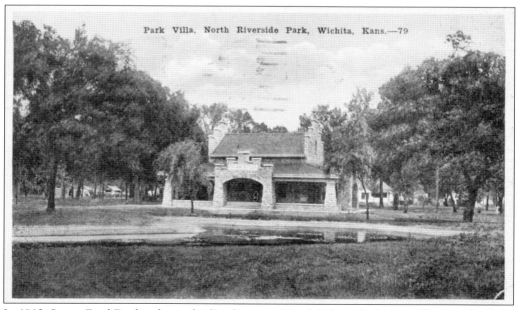

Park Villa, North Riverside Park, Wichita, Kans.—79

In 1912, Laura Ford Buckwalter, who lived next to North Riverside Park, realized with all the attractions in the park there was still no public picnic shelter. She convinced the city commission to build one, and after obtaining donated materials, she was able to submit the cheapest bid to construct it. Local architect Ulysses Grant Charles donated his services as designer. Park Villa was dedicated on June 2, 1913.

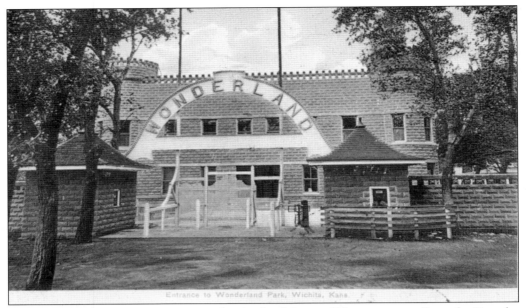

Entrance to Wonderland Park, Wichita, Kans.

An island of more than 50 acres once lay in the Arkansas River upstream from the Douglas Avenue Bridge. Known as Ackerman Island, it had a large amusement park on its north half from 1906 to 1917 called Wonderland. This was the entry gate to the park. People could travel to Wonderland on streetcars via a loop bridge built out from the east bank of the river.

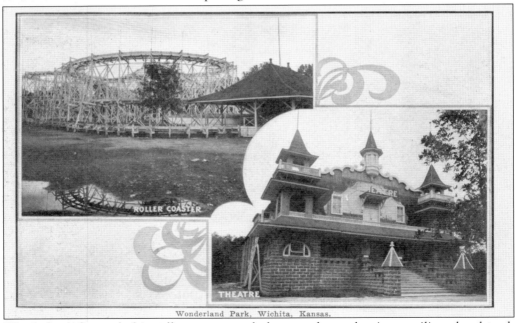

Wonderland Park, Wichita, Kansas.

Wonderland featured this roller coaster and theater, plus a dancing pavilion, bandstand, carousel, and many other attractions. The theater could seat over 1,100 people for the vaudeville shows it typically hosted. Blue laws that forbade charging admission on Sundays contributed greatly to its demise in 1917, as did the increasingly common pastime of taking pleasure drives in automobiles.

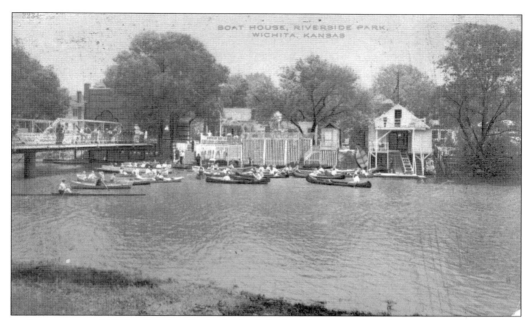

In the summer of 1898, after the city had raised the level in the Little Arkansas River by building the Central Avenue Dam, Reuben C. Israel bought six rowboats for his two sons to rent out to the public. By 1905, boating had become so popular that he established the Riverside Boat House next to the Murdock Avenue Bridge on the east bank. It was a place of recreation in Wichita for the next 60 years.

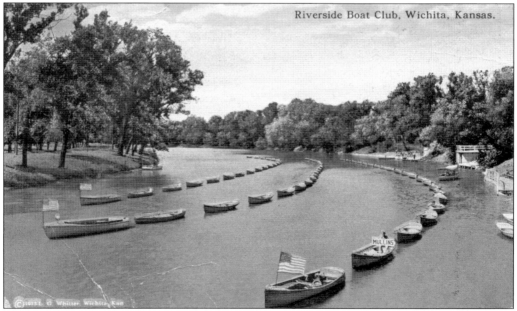

R.C. Israel purchased a motor launch in 1911 and a fleet of Mullins pressed-steel rowboats. The motor launch could be hired for cruises on the river and was also used to retrieve boats at the end of the day. Israel strung the rowboats out into three long lines upstream of the Murdock Avenue Bridge for this publicity shot. The motor launch is at the head of the center line.

Lagoon, Oak Park, Wichita, Kansas

7A-H2855

In 1923, the city purchased 23 acres of oak woodland adjoining North Riverside Park. Land that had been platted for an upscale residential neighborhood was instead preserved as a wooded oasis for all to enjoy. What would have been the main street of the neighborhood became instead a sinuous drive through the middle of the woods. This lagoon feature was added in 1928.

SCENE AT LINWOOD PARK, WICHITA, KANSAS 6A-H1297

Linwood Park, in southeast Wichita, was donated to the city in 1887. However, it did not get developed right away. People nearby used the park for grazing their cattle. In 1918, the city moved all the hoof stock from the Riverside Park Zoo there. This shelter was constructed in 1936 at the north end of Linwood Park and is still present. The park also now contains a recreation building and a park greenhouse.

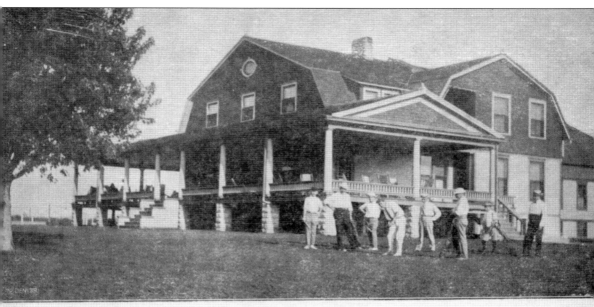

Country Club, Wichita, Kansas.

Wichita's first golf was played in 1897 on the prairie south of Fairmount College, where Fairmount Park is today. The game was brought to Wichita by Clifford Clark, a professor of Latin at the college. The Braeburn Golf Club was formed and a clubhouse was built at Sixteenth Street and Fairmount Avenue. There were only six holes, and tomato cans were used for the cups. Cattle kept the course mowed but also created unusual hazards for the golfers. In 1900, the Wichita Country Club formed and leased 80 acres in the College Hill section of town, two miles south of the college. It developed a golf course and used the former home of Willis Proudfoot at 303 Circle Drive as a clubhouse. It built this clubhouse in 1903 southwest of the intersection of Fountain Avenue and English Street. This view looks northeast and shows the wide wraparound porch on the clubhouse and some golfers practicing nearby.

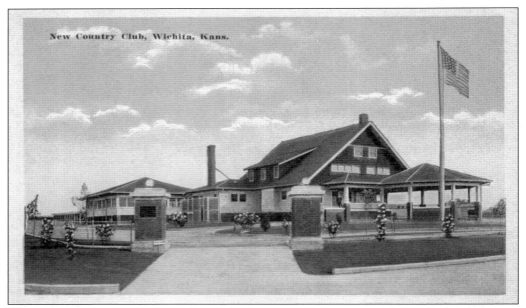

The Wichita Country Club purchased 80 acres northeast of Central and Hillside Avenues in 1910 and built an 18-hole course. This card shows the street entrance and the northwest side of the new clubhouse. The land where the first course was became College Hill Park in 1924, and this course became McDonald Golf Course after the club moved to East Thirteenth Street in 1950. Neither this nor the first clubhouse still exists.

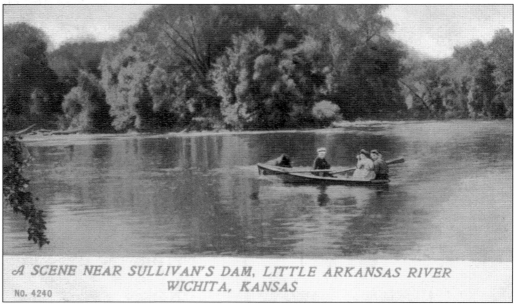

A dam was put on the Little Arkansas River above Wichita in 1874 to divert water into Chisholm Creek for use by a gristmill. The dam was built near property owned by the Sullivan family and came to bear their name. This postcard shows some people boating on the impounded water above the dam, which became a popular recreational spot in the years between 1910 and World War I. (Courtesy Hal Ottaway.)

The Arkansas Valley Interurban (AVI) electric railroad was completed north from Wichita to Valley Center in 1910 and to Newton in 1911. Its route went right past Sullivan's Dam, so the AVI developed a resort area along the river called Walnut Grove, charging 10¢ for tickets from Wichita. Walnut Grove held Wichita's first air show on May 4–6, 1911, and thousands of people rode out to see the spectacle. These two families enjoyed picnicking on July 4, 1913, the same day that 3,000 people visited Walnut Grove. Although many came each summer to picnic and swim in the river nearby, the strongly seasonal nature of the business hurt its ability to make money, and the railroad stopped operating Walnut Grove after 1915, although it kept a station there until it ceased passenger service altogether in 1938. Both Walnut Grove and Sullivan's Dam are long gone now, but this real-photo postcard reminds us of the happy times many people enjoyed there.

BIBLIOGRAPHY

Bentley, Orsemus H. *History of Wichita and Sedgwick County Kansas*. Chicago: C.F. Cooper & Co., 1910.

Henline, Beverly A. *In the Whirligig of Time: Pages from Wichita History*. Wichita: Wichita/Sedgwick County Historical Museum Association, 1995.

Long, Richard M. *Wichita Century*. Wichita: Wichita Historical Museum Association, Inc., 1969.

Mason, James E. *Wichita's Riverside Parks*. Charleston, SC: Arcadia Publishing, 2011.

Miner, Craig. *Uncloistered Halls: The Centennial History of Wichita State University*. Wichita: Mennonite Press, 1995.

———. *Wichita: The Early Years, 1865–80*. Lincoln: University of Nebraska, 1982.

———. *Wichita: The Magic City*. Wichita: Wichita/Sedgwick County Historical Museum Association, 1988.

Price, Jay M. *Wichita: 1865–1930*. Charleston, SC: Arcadia Publishing, 2003.

Reeve, Juliet. *Friends University: The Growth of an Idea*. Wichita: Wichita Eagle Press, 1948.

Ross, Hal, Hal Ottaway, and Jack Stewart. *Peerless Princess of the Plains: Postcard Views of Early Wichita*. Wichita: Two Rivers Publishing Co., 1976.

Rothman, Hal K. *A Tradition of Caring: 1889–1989*. Wichita: St. Francis Regional Medical Center, 1988.

Rydjord, John. *A History of Fairmount College*. Lawrence: Regents Press of Kansas, 1977.

Tanner, Beccy. *Bear Grease, Builders and Bandits*. Wichita: Wichita Eagle and Beacon Publishing Co., 1991.

Tihen, Dr. Edward N. *Dr. Edward N. Tihen's Notes from Wichita Newspapers*. Special Collections and University Archives, Wichita State University Libraries.

Van Meter, Sondra. *Our Common School Heritage*. Wichita: Kansas Board of Education, 1977.

INDEX

Buildings that are in the National Register of Historic Places (NR) show their year of addition in parentheses.

Discover Thousands of Local History Books
Featuring Millions of Vintage Images

Arcadia Publishing, the leading local history publisher in the United States, is committed to making history accessible and meaningful through publishing books that celebrate and preserve the heritage of America's people and places.

Find more books like this at
www.arcadiapublishing.com

Search for your hometown history, your old stomping grounds, and even your favorite sports team.